PAINTING LIGHT & SHADOW

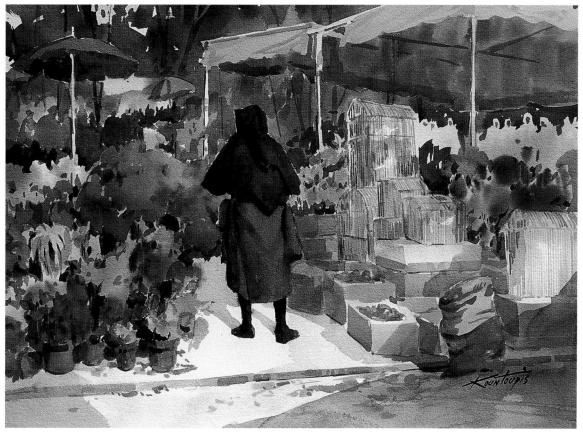

Granada, Spain–George E. Kountoupis

First published in the United States of America by:

Quarry Books, an imprint of

Rockport Publishers, Inc.

33 Commercial Street

Gloucester, Massachusetts 01930-5089

Telephone: (508) 282-9590

Facsimile: (508) 283-2742

Distributed to the book trade and art trade in the United States by:

North Light Books, an imprint of

F & W Publications

1507 Dana Avenue

Cincinnati, Ohio 45207

Telephone: (800) 289-0963

Other Distribution by:

Rockport Publishers, Inc.

Gloucester, Massachusetts 01930-5089

ISBN 1-56496-348-9

10 9 8 7 6 5 4 3 2 1

Designer: Kristen Webster–Blue Sky Limited
Cover Image: *Frey's Barn–Morning,* M.C. Kanouse
Back Cover Images: *(left to right) Bamboo VIII,* Allison Christie
Family Man, Douglas Wiltraut
Granada, Spain, George E. Kountoupis

Manufactured in Hong Kong.

BEST OF WATERCOLOR

painting LIGHT & SHADOW

selected by betty lou schlemm/edited by sara doherty

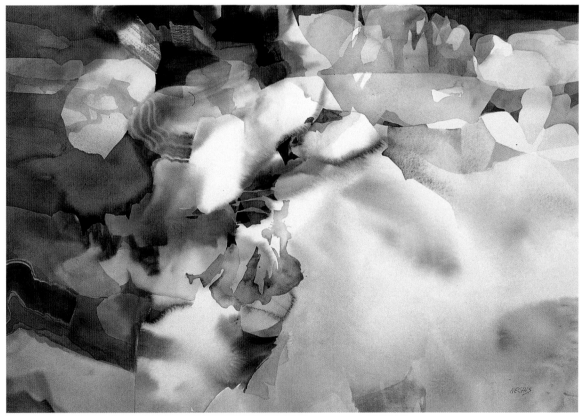

Lunar Series: Moon in Scorpio–Barbara Nechis

Quarry Books
Gloucester, Massachusetts
DIstributed by North Light Books
Cincinnati, Ohio

introduction

There is poetry out-of-doors—it is well for us to learn from nature. It is important to observe the light from the earliest of dawn through noon day to the last light of evening. At every moment the light of day changes, ever so slowly, so subtly we hardly notice. This colored light mixes with the air and touches all objects in our landscape. The beautiful blue sky plays upon upward planes. It runs across our shoulders and through our hair on the very tops of our heads. This same colored light falls on the treetops, on the grass, on roofs of our houses; it glistens on the back of a horse as it trots by. This light shines equally on all things and ties our beautiful world together.

Who has not felt the warm sun and seen how its light mixes with all the local color it touches? It makes things light as it adds its color to the forms in our landscape. We notice how the moisture in the air changes the intensities and values of the light and how it mixes to create its own color. A good painting is touched with this color, one color, one light, seen as it moves through air and space. And as the light moves towards us, it intensifies in its brilliance until finally it reaches the closest of the picture planes.

Without light how could there be shadow? As the light adds its warmth, the shadows play upon the forms in all their coolness. These shadows remain the same in color throughout the painting, only losing intensity as they recede into the picture plane. Always the light of the sky affects those shadows on the upward planes in our landscape.

In the past, shadows were painted dark, colorless. They were painted then as we now would only paint in north studio light or at twilight, that strange and colorful last light of day. The shadows were dramatic in their starkness, making the air and light even warmer and brighter. It was Caravaggio who first lit a candle behind the models so we could enter the shadows and move through them. Then came Impressionism, and the great painters observed that shadow and light were complements to each other, one always being stronger in intensity than the other. They showed how at noon time, colored light from the sun joins the colored light of the sky and mixes together, beating down upon the earth and sending up a magnificent reflected light. It was Sargent and Sorolla and many others who took this light and added it to local color.

Painters began to leave the local color out when modern painting began. Perhaps if the sky in early morning was made with a soft yellow light with the pearly gray-blue sky over it, the blues were left out and only the yellows were painted. Or if a cool purple blue shadow ran across the gray trees, the gray is left out and only the purple-blue is painted. Even so, our landscape will appear true to our eyes.

So much each artist adds to his painting by the understanding of light and shadow. Each one works in their own creative way. We hope that this book will show the many artists' ventures into the world of light and shadow.

Betty Lou Schlemm, A.W.S., D.F.

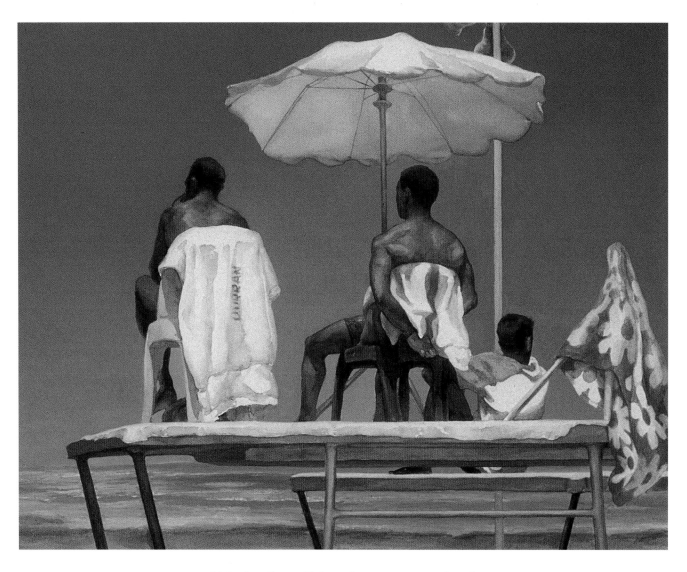

YOLANDA FREDERIKSE
Bay Watchers
22" x 30" (56 cm x 76 cm)
Arches 300 lb. cold press

Light, the effects of light, and transparency are the subjects of *Bay Watchers*. Intense summer sun penetrates the thin fabric of the beach umbrella and is absorbed by and reflected on the draped towels, the platform surface, and the wet skin of the lifeguards. The brilliant blue background is meant to be intimate yet isolating, portraying the lifeguards as both ordinary and monumental. I used a combination of staining and opaque watercolors, allowing the paper and paint to dry between glazes.

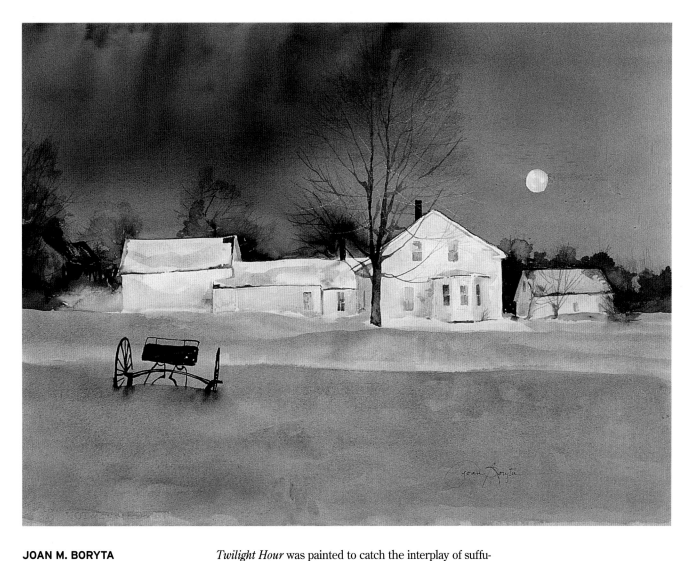

JOAN M. BORYTA
Twilight Hour
22" x 30" (56 cm x 76 cm)
Winsor and Newton 140 lb. cold press

Twilight Hour was painted to catch the interplay of suffusive light cast by the setting sun and the rising moon. While the sun is still high enough to reflect glowing light off the windows, it is also low enough to cast a subtle shadow onto the foreground. I selected a strong, dense color for a one-coat application of the sky and a transparent layering of cool blue shadow in the foreground snow, keeping in mind the importance of luminosity.

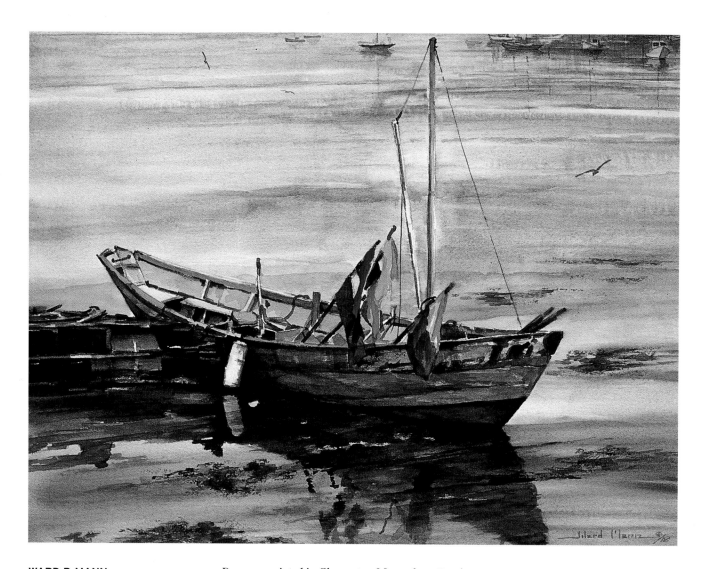

WARD P. MANN
Dory
19.5" x 25" (50 cm x 64 cm)
Arches double elephant 240 lb. cold press

Dory was painted in Gloucester, Massachusetts where I found a simple subject that became more interesting through the enhancement of the contrast between bright and muted colors, detail and suggested form, and most importantly, light and dark. Form and cast shadows are essential to the composition's completion and they make a strong statement about the boat and water reflections and surface detail. Transparent watercolor was ideal for recreating the translucent nature of shadows. I painted around the white areas with the darkest dark and then worked dark into the shadow of the dory.

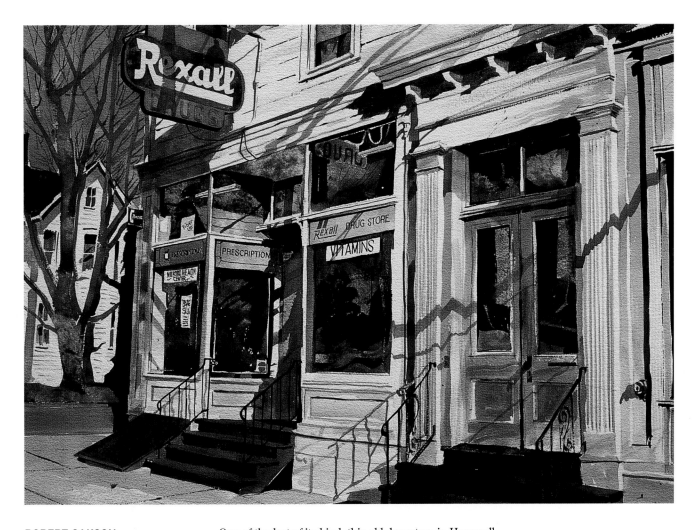

ROBERT SAKSON
Rexall
22" x 30" (56 cm x 76 cm)
Arches 140 lb. cold press rough

One of the last of its kind, this old drugstore in Hopewell, New Jersey caught my attention. The shadow areas were done using a mixture of Van Dyck brown, ultramarine blue, and Winsor violet mixed with aquapasto medium to retain life. The shadows strengthen the whites and hold them together. Colors were applied directly on the paper to keep the image fresh.

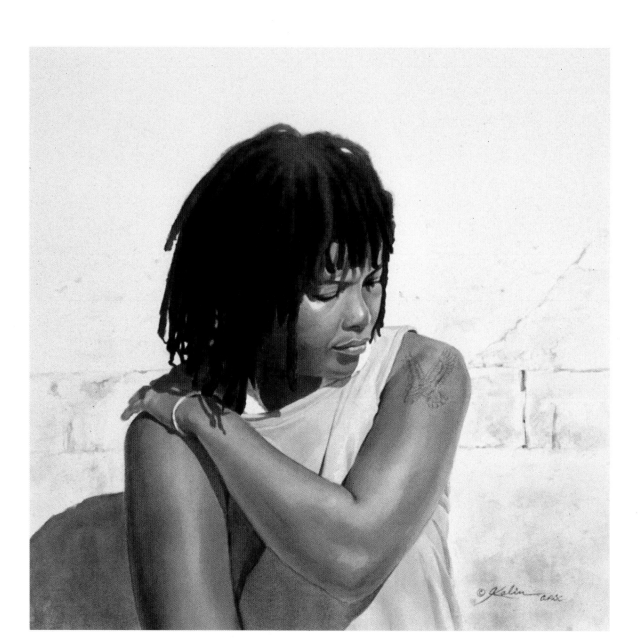

JEAN KALIN
Caribbean Series: Cayman Eagle
18" x 18" (46 cm x 46 cm)
Arches 140 lb. cold press

On Grand Cayman Island, the hot sun brings out texture and contrast—sheen on skin, flat black braids, bleached concrete, and strong shadows. Since I enjoy painting light and people, I was drawn to this woman with her tattoo and casual posture. Working from color notes and photographs I started painting wet-in-wet, pushing the colors, and applying many layers, letting each dry completely, using less and less water as I continued. I finished with drybrush for details and to sharpen the textured effects.

MARGARET EBBINGHAUS BURCH
Honey and Orange Marmalade
22" x 30" (56 cm x 76 cm)
Arches 300 lb. cold press

I arranged the objects in *Honey and Orange Marmalade* into a vignette style with a sheet of glass positioned behind them to reflect the light and achieve a high-keyed look. The work was unified using techniques such as wet-in-wet, transparent layers, working from light to dark, and large areas to small. I emphasized the texture in the many types of glass vessels used—transparent, reflective, and flat, dull pieces. Cast shadows added a sense of dramatic light and natural light added a sense of nostalgic warmth.

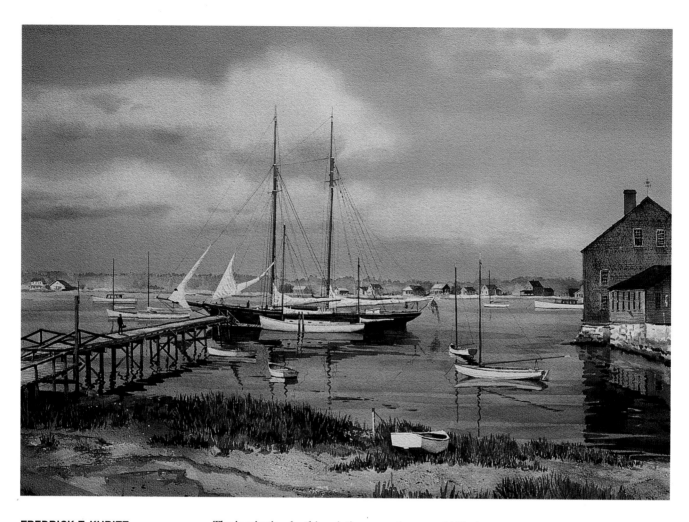

FREDRICK T. KUBITZ
South Wharf–Padanaram, New Bedford, MA c. 1920
22" x 30" (56 cm x 76 cm)
Arches 300 lb. cold press

The inspiration for this painting came from an old black-and-white photograph showing the serenity of summer bathed in direct sunlight. Warmth in the light-sand beach was repeated in the buildings, dock, distant background, and lazy summer clouds, and was complemented by darker blue water and sky. Horizontal bands of warm and cool colors were purposely alternated to enhance the feeling of light. The white accents reinforcing the presence of direct sunlight were masked prior to starting the first washes. Darker values were introduced with the beach grass, buildings, and large schooner.

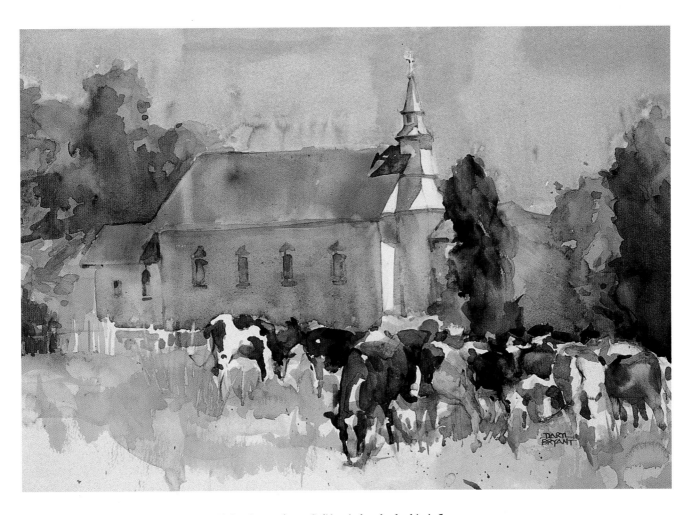

DARYL BRYANT
Cows at Church
15" x 22" (38 cm x 56 cm)
Winsor and Newton 140 lb. cold press

Living in southern California has had a big influence upon my choice of color, location, and subject. The play of light upon objects and the colors in shadows have long fascinated me. Using a palette of mostly transparent colors, I began painting washes with plenty of water and culminated with heavier applications of pure color applied directly to the paper. Located in a charming small town, the church is where my sister was married and provides me with the emotional connection to my subject that I find an important element in my work.

MARGARET R. MANRING
Joanna in Dress-Up
14" x 20.5" (36 cm x 52 cm)
Arches 140 lb. cold press

I am always looking for light, its reflection, absorption, movement, and how it transforms the objects in its path. To portray light, I make use of the transparency of watercolor, the characteristics of the paper, and the simple techniques of direct painting—wet-in-wet, scrubbing, and some drybrush. I pay close attention to details like highlights. There are no highlights in the eyes due to the diffused light beneath the hat brim; and in the more direct light, the lip highlight is soft. Most defined is the bead highlight, because it lies in the strongest light. Black feathers and some areas of velvet serve as foils for the light-reflective portions of the painting.

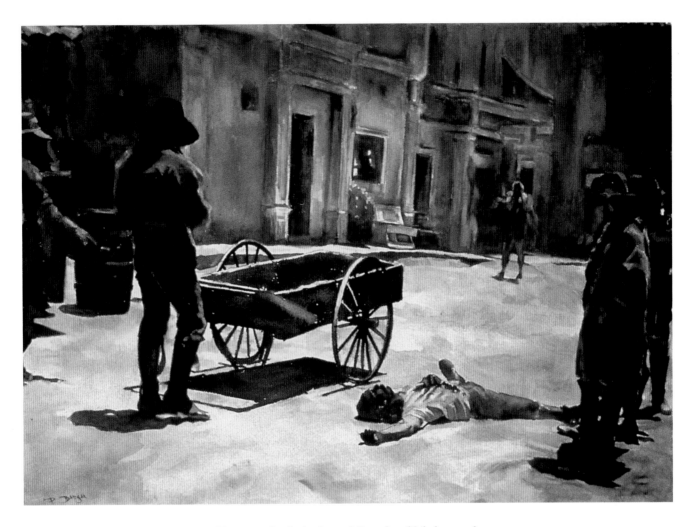

PAT BERGER
Is Yesterday, Today, Tomorrow?
22" x 30" (56 cm x 76 cm)
Arches 300 lb. cold press

To create the desired mood, I used multiple layers of blue-gray and brownish washes, overlaying the glazes. The painting depicts past violence that continues into the present and, perhaps, the future. Mystery was created by keeping the figures in shadow with the ground providing the only light and the prone figure having the only defini-tion. Use of shadow interconnects images of the past and present.

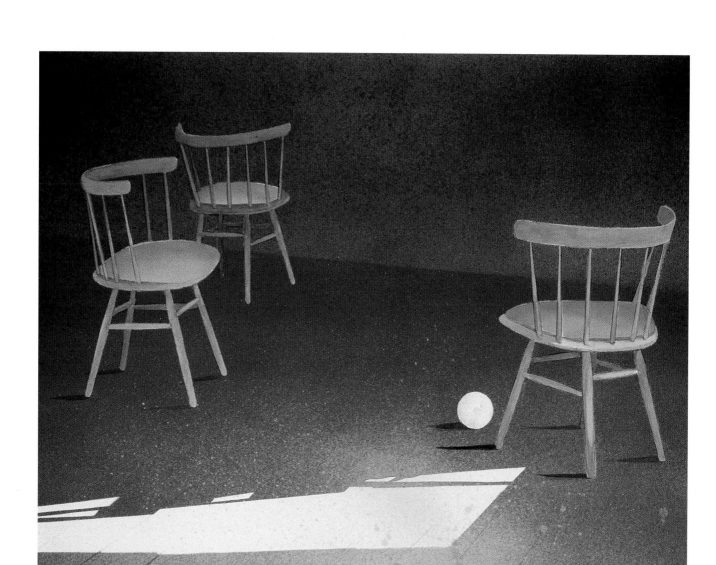

VIRGINIA ABBATE THOMPSON
The Fourth Chair
22" x 30" (56 cm x 76 cm)
Lanaquarelle 140 lb.
Watercolor with gouache and colored pencil

Many of my paintings use light and shadow and suggest something beyond what is shown. My three sons used these chairs when they were little. In this painting, "the fourth chair" represents the fourth child I wanted, but never had. Sunlight coming through the kitchen door leaves a shadow of the unseen chair. Using primarily transparent watercolor, I airbrushed the floor and walls and used splatters of gouache to indicate points of light and reflection and colored pencil for other detail.

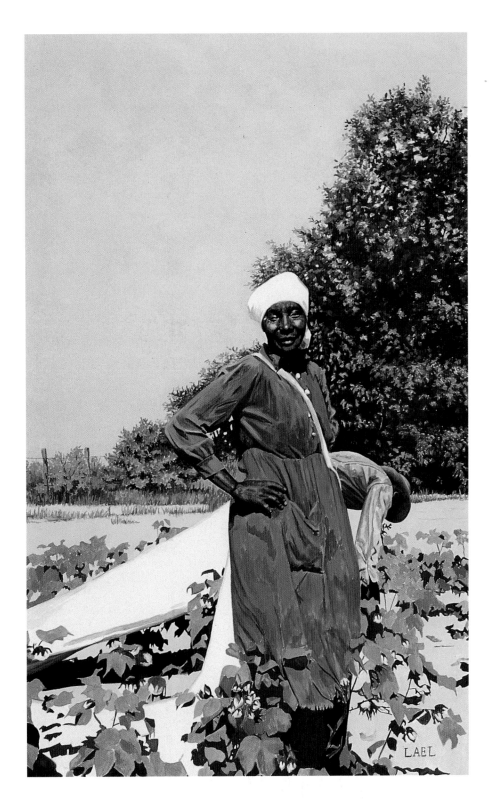

LAEL NELSON
100% Cotton
39" x 27" (100 cm x 69 cm)
Arches 300 lb. cold press
Watercolor with gouache

Once the initial drawing was
completed, values were painted
in burnt umber, dark areas were
applied in a thick paste form, the
middle values were washed in, and
the white areas were simply left
unpainted. A dark underpainting
makes the colors richer and more
intense with monochromatic colors
enhancing the work's strong state-
ment. High contrast creates the
light and brings the figure bathed
in sunshine to life.

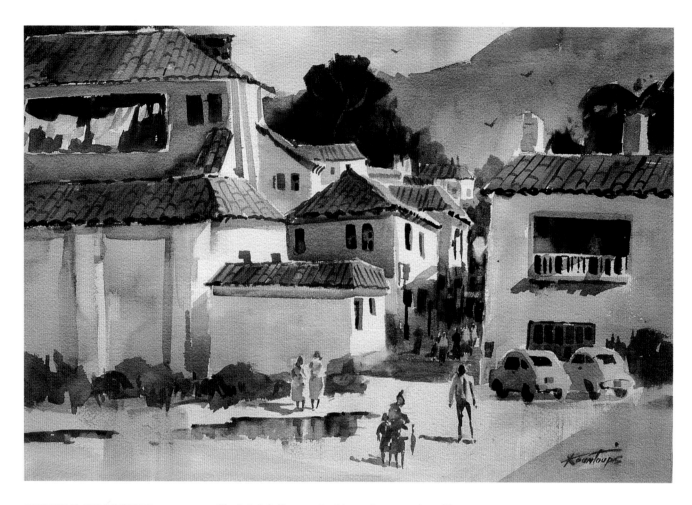

GEORGE E. KOUNTOUPIS
Granada, Spain
22" x 30" (56 cm x 76 cm)
Arches 300 lb.
Watercolor with acrylic

The brightly lit areas in this work are produced by surrounding the pure white of the paper with darks. Middle values relating to the light were made slightly lighter and warmer. The subject was side-lit, allowing me to place the strong lights on the buildings facing the sun. The strongest darks were then carefully placed next to these sunlit areas. In proportioning this work, I allotted approximately three-fourths of the painting for shadow and one-fourth for light.

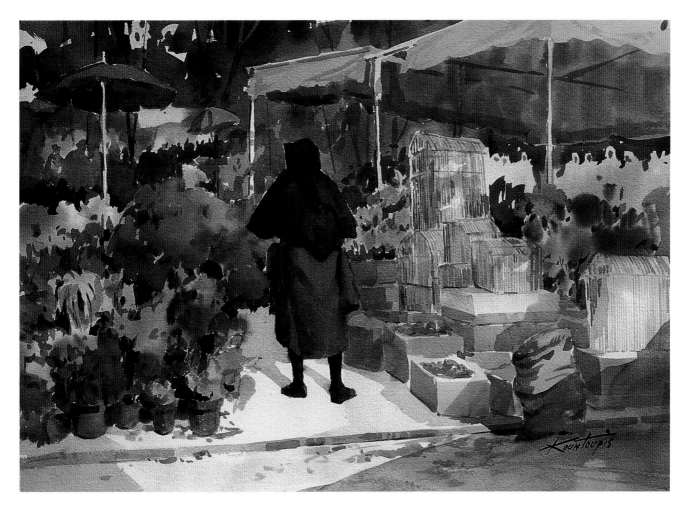

GEORGE E. KOUNTOUPIS
Flower Market–Portugal
22" x 30" (56 cm x 76 cm)
Arches 300 lb.

By placing the painting three-fourths in shadow of a middle value as shown, I used darks and lights to emphasize the figure and flowers, with the lightest value against the figure and the darkest value being the figure itself. Colorful flowers are dramatized by maintaining shadows with grayer and cooler tones. The arrangement of the shadows frames the subject and gives a sense of light direction.

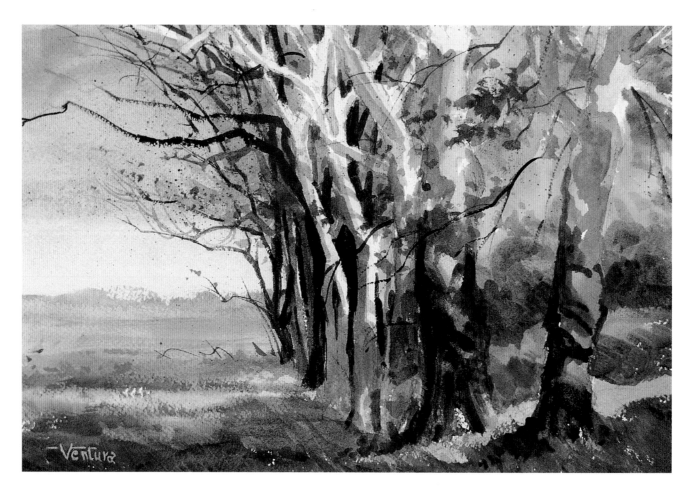

ANTHONY VENTURA
Edge of the Woods
10" x 14" (25 cm x 37 cm)
Arches 140 lb. cold press

The beautiful play of light coming through the trees, emphasizing the sycamores, first caught my eye. With this image in mind, I kept the colors warm and vibrant, working wet-in-wet on dry paper, shaping the sycamores as the work progressed. Shadows were painted with reflected light, then the darker trees and shadows were added to strengthen the light tones and add balance. Light was achieved by carefully using the white of the paper, warm colors, and dark accents.

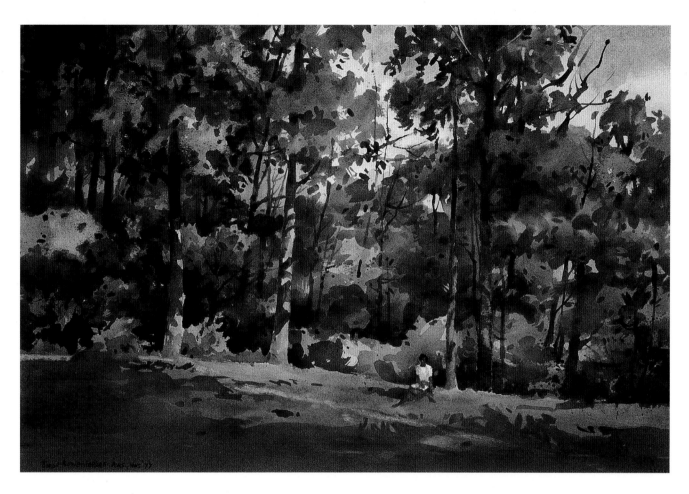

JORGE BOWENFORBÉS
Reading Shakespeare
22" x 30" (56 cm x 76 cm)
Arches 140 lb. cold press

I created a visual interpretation of depth by painting the entire foreground in shadow. This is important when working with an almost monochromatic palette, where the darks are used to establish form and animate the trees. Gradating shadows established convincing contrasts throughout the painting, with glazing serving as the predominate technique.

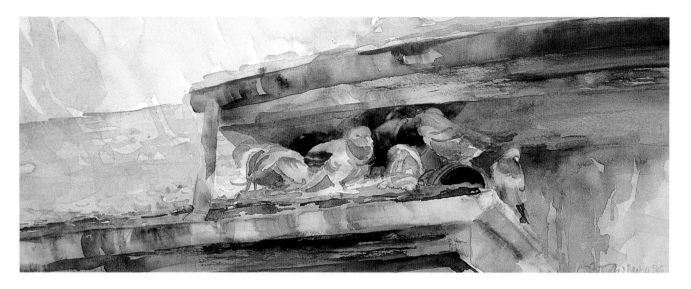

PRISCILLA E. KREJCI
Under the Eaves
11" x 30" (28 cm x 76 cm)
Lanaquarelle 300 lb. cold press

This painting was inspired by birds I found huddled under the eaves during a cool, rainy day in Lucerne, Switzerland. The muted daylight provided faint shadows that I was able to recreate by letting the paint and water interact with a little directional guidance from me.

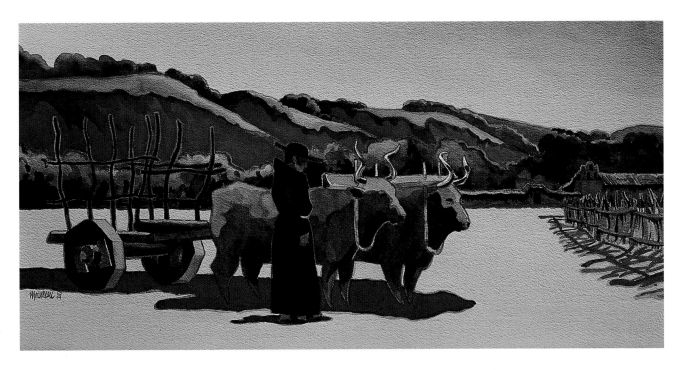

JOANNA MERSEREAU
Noon at Mission La Purisima
14" x 30" (36 cm x 76 cm)
Lanaquarelle 300 lb. cold press

The theme of *Noon at Mission La Purisima* was the concept of brilliant, blinding, noonday light as seen at a California mission. This subject was chosen as one of a series of paintings illustrating my book, *Dark Mission*. Transparent watercolor was used, with complementary colors providing outlines and creating an aura around the various elements.

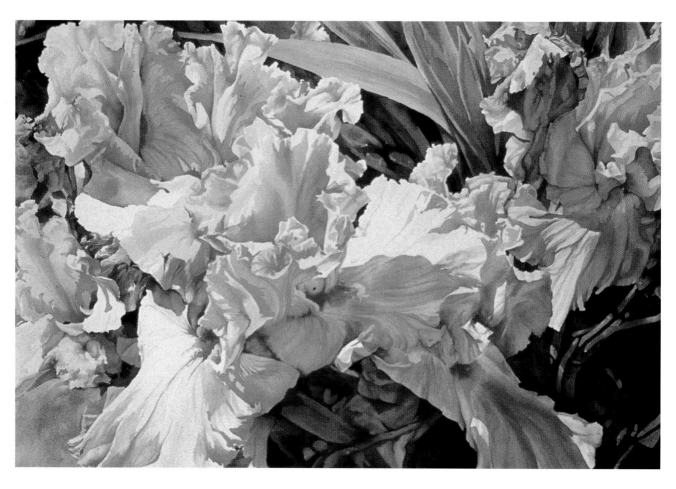

JEAN COLE
Iris #3
30" x 45" (76 cm x 114 cm)
Arches 140 lb. cold press

Before photographing a subject, I look for dramatic lighting, high contrast, and good shadow forms that help describe it. I take pictures only on sunny days, not minding if some colors burn out because the shadows then take on a lot of color. Transparent watercolor works best to capture the luminosity of color in floral subjects and I use layered glazes to build up color for depth and intensity. I combine several colors in one area, first painting the local color then going over with a shadow color, trying to find as much color as possible in the shadows.

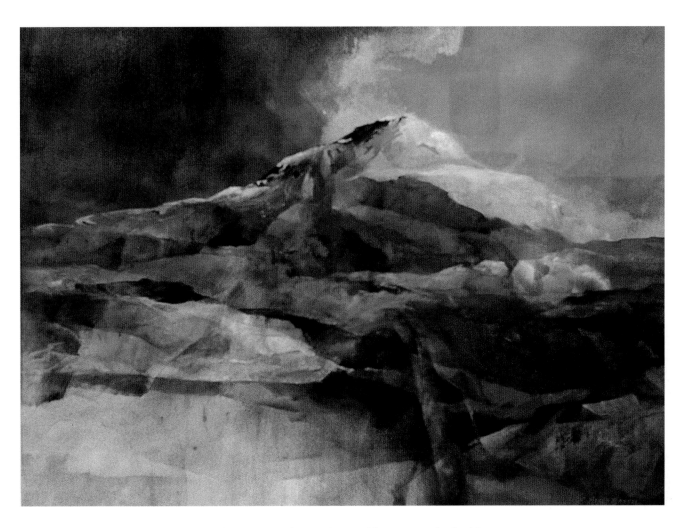

MARGO BARTEL
Majestic Sentinel
22" x 30" (56 cm x 76 cm)
Arches 140 lb. cold press
Watercolor with acrylic

I do not approach my painting with a preconceived subject in mind. Instead, I find my subject by working with thin glazes of color over color, playing dark against light with shape and color variations, and using differing brushstrokes. While trying to stay as abstract as possible, I am always excited when the subject begins to take form.

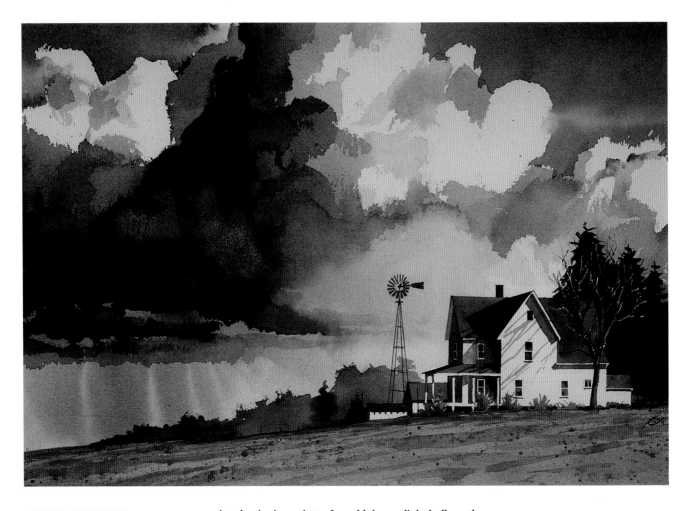

JACK R. BROUWER
Afternoon Rain
14" x 21" (36 cm x 53 cm)
Arches 140 lb. cold press

As a beginning painter, I would draw a light bulb on the border of my paintings to remind me of the constant importance of light. Now, I watch for unexpected light that can create drama and excitement in my painting. It was the sudden emergence of the sun after a rainstorm that produced such an effect in *Afternoon Rain*. I paint in transparent watercolor letting the white of the paper carry the strongest whites and add contrast with strong deeper colors that maximize excitement and interest.

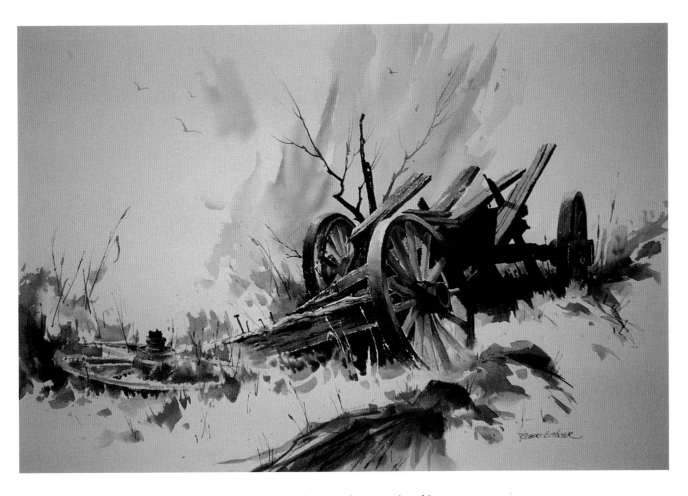

ROBERT E. HEYER
Prairie Wagon
22" x 30" (56 cm x 76 cm)
Arches 140 lb. rough

I find interesting shapes and textures in subject matter that is in some stage of deterioration. Shadows in my paintings express mood, act as a transitional element between shapes, and describe a surface attribute such as rough, weathered wood and rusted iron wheels. Keeping the white of the paper as my white, I use a rough paper to produce the needed texture along with transparent watercolors.

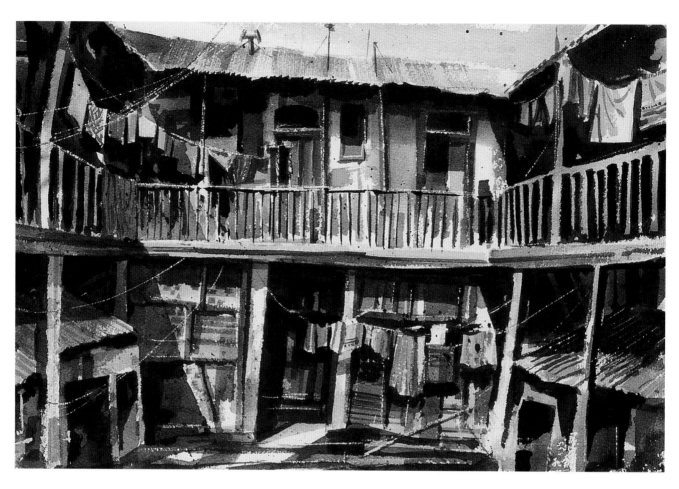

MONROE LEUNG
Summer in Soweto
20" x 25" (51 cm x 64 cm)
Arches 140 lb. rough

Summer in Soweto was made from on-location sketches and photos. The subject presented ideal conditions for sunlight and shadows; the corrugated roof and balcony cast deep shadows that contrasted sharply with the sunlit areas. Shadows gave depth and vibrancy to the painting and most of the paint was applied directly on a dry surface or over dry color.

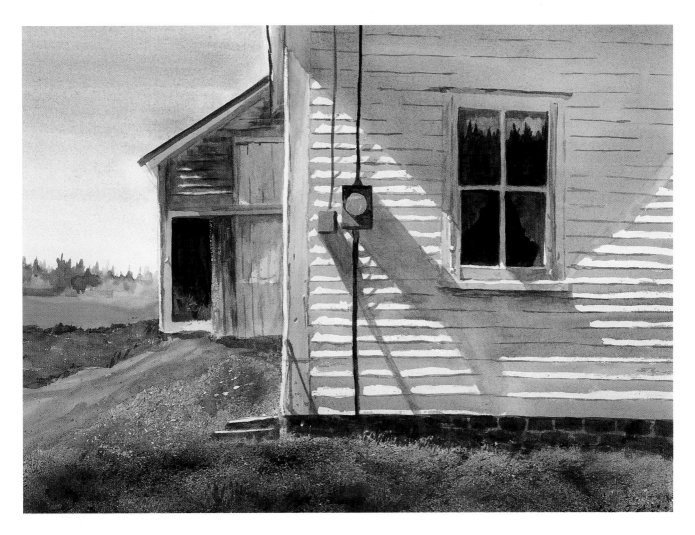

NAT LEWIS
Salt Water Farm
16.5" x 23.5" (42 cm x 60 cm)
Arches 300 lb. hot press

Fascinated by old white houses, it is the dramatic patterns of light and dark, rather than the houses themselves, that inspire me. While most house paintings depict shadows cast on sunny surfaces, I have chosen an opposite approach, capturing fleeting moments when the sun moves from one side of the house to the other, leaving narrow shafts of light within the shadow. I began by covering the entire surface with a pale yellow wash and masking the sun glints before painting the shadow color, keeping the wash clean and uninterrupted. Sunny patterns are then exposed when the masking is removed.

ALLISON CHRISTIE
Bamboo VIII
19" x 14" (48 cm x 36 cm)
Arches 300 lb. cold press

My main focus is on the designs created by cast shadows and the forward movement these patterns provide for a realist's subject. After sketching in the dominant foreground and midground lines, I determined where the shadows should lay and painted them first. Using burnt sienna and French ultramarine as my base, a wide range of soft warms to soft cools to ink black was achieved. Surrounding color influences were added for interest and contrast and the shadows helped heighten the contrast of the older, drier leaves with the younger, supple, green leaves.

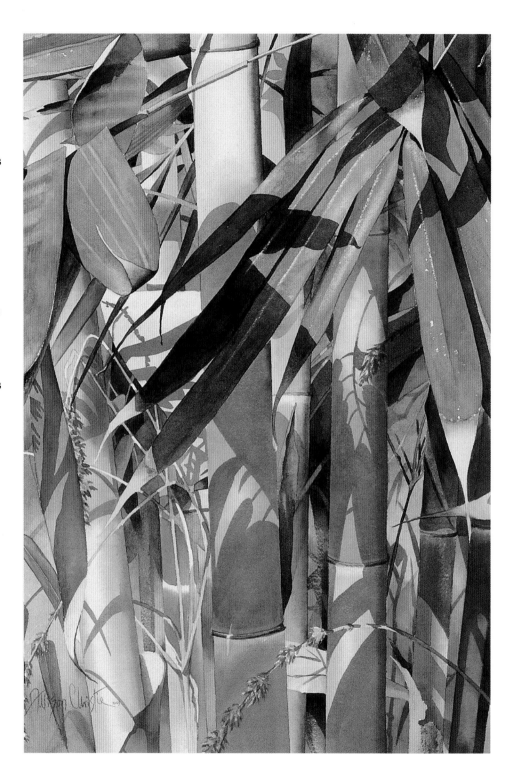

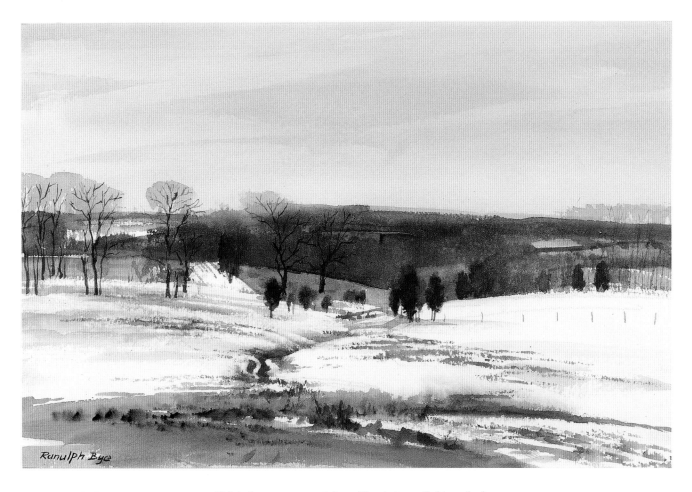

RANULPH BYE
Bedminster Landscape
15" x 21" (38 cm x 53 cm)
Arches 140 lb. cold press

Painted on an overcast day without strong light or shadows, *Bedminster Landscape* depicts strong value contrasts of woods and fields against white snow. The snow areas are untouched paper with slight variations where the snow has melted. Drybrush was used in some areas to indicate grassy texture. With the absence of sunlight, values were simplified and darker than those found on a clear day. Spontaneity was the key in this work, with every area painted directly and very little going over later.

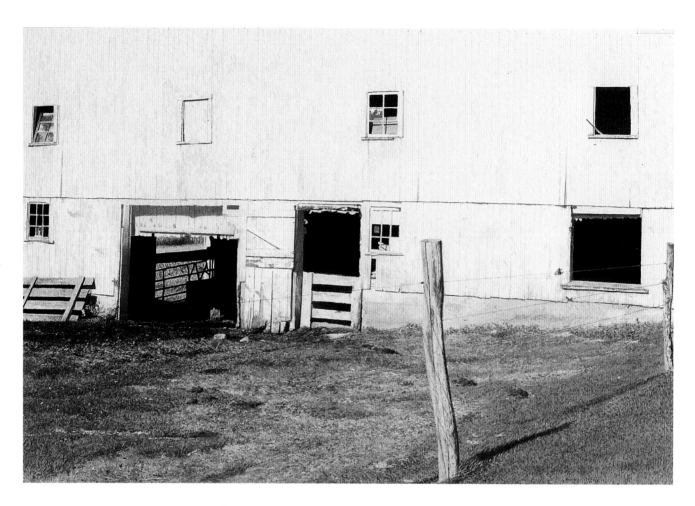

RICHARD J. SULEA
Barn with Yard
14" x 21" (36 cm x 53 cm)
Arches 300 lb. cold press
Watercolor with gouache

The use of light to define form is of utmost importance in my work. In painting architectural forms in sunlight, careful attention to value is achieved by successive light washes that are allowed to dry before the next one is applied. Three to ten washes may be applied to any given form to achieve the correct value relationships in the composition.

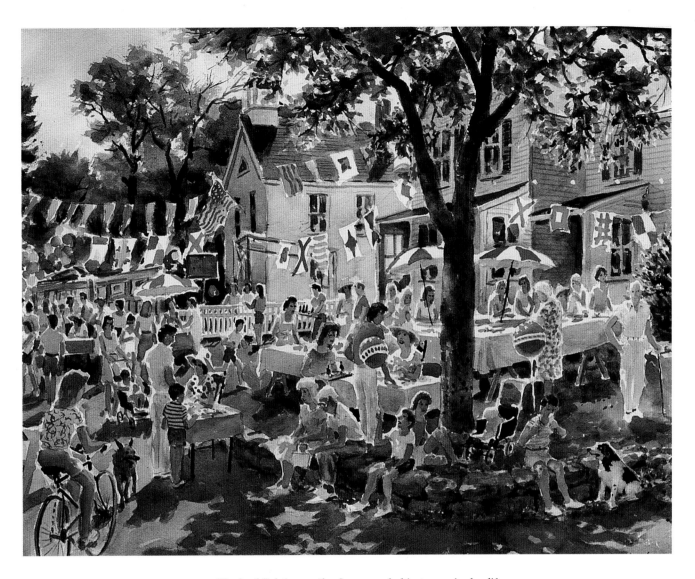

S. OHRVEL CARLSON
Annisquam Fair
17" x 23" (43 cm x 58 cm)
140 lb. cold press

The backlighting on the figures and objects required a different pattern of sunlight and shadow than would occur if the light came from the left or right. Beyond that, I used a traditional English technique of building up layers of transparent color from light to dark and transparent to opaque.

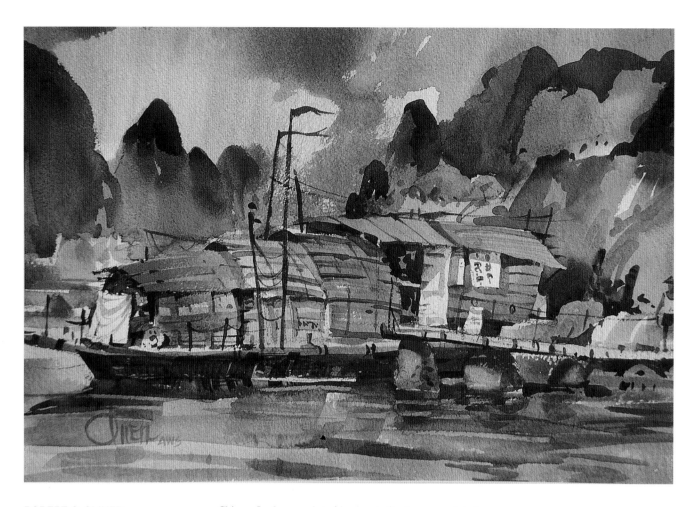

ROBERT S. OLIVER
Chinese Junk
14" x 20" (36 cm x 51 cm)
Arches 140 lb. rough

Chinese Junk was painted in my studio from annotated sketches done on location. The atmosphere of the setting was clear and crisp and called for a strong value change throughout the painting. Using wet-in-wet and drybrush techniques, I utilized the rough surface of the paper to reflect the darks and lights while softening the edges.

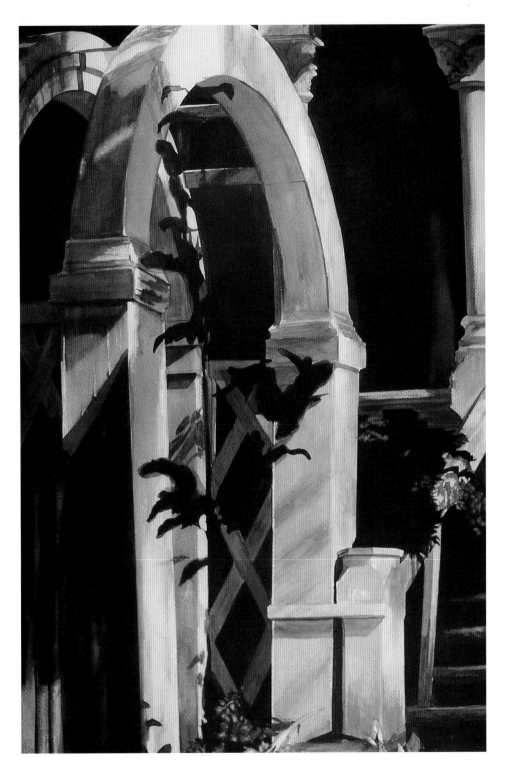

HENRY W. DIXON
Arches
34.5" x 20.5" (88 cm x 52 cm)
Arches 140 lb.

Blending light and shadow to provide the basis of a pleasing composition, I paint on dry paper, which allows me to use the white of the paper for areas of lightest light. Using the light with varying shadow values lets me bring out the main artistic qualities of the work's subject, the arches.

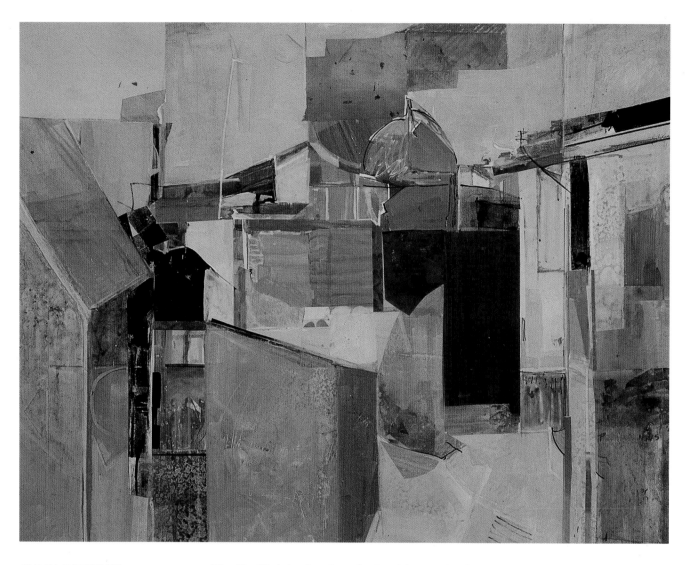

GLORIA PATERSON
Cibola
31" x 40" (79 cm x 102 cm)
Museum board
Watercolor with acrylic, markers,
and crayon

The title *Cibola* is taken from the Spanish conquistadors who pursued the seven cities of Cibola, where the streets were reportedly paved with gold. Initial studies of the painting were cut, torn, and applied as collage elements to achieve a flat dimension, interesting surface, and straight edges. These areas were then painted over, some by using brayers. Dark, medium, and light grays and blacks were used to create movement throughout the painting.

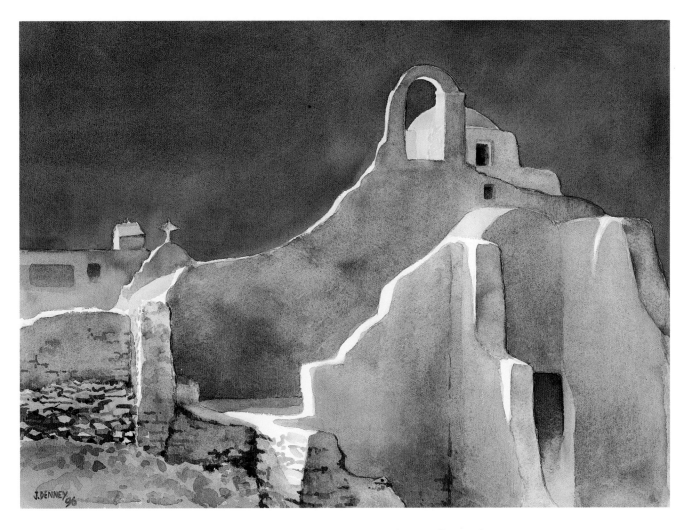

JACK DENNEY
Church Ruins–Mykonos
16" x 22" (41 cm x 56 cm)
Arches 300 lb. cold press

Shadows enhance composition, mood, storytelling, and light as well as presenting a stage for complementary color value. The repeated shapes of the major walls and the dominant backlit sky in *Church Ruins—Mykonos* required imaginative use of a full palette. A primary challenge was representing the whitewashed walls using color. The sky and walls were painted wet-in-wet using transparent watercolors.

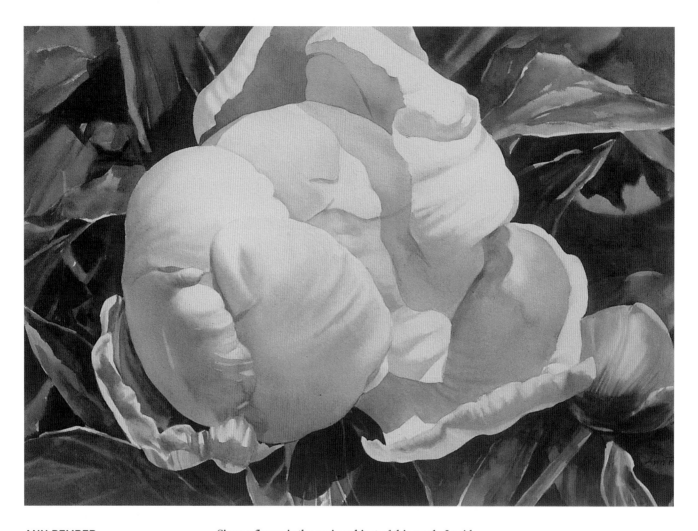

ANN PEMBER
Peony Birth
14.5" x 21.5" (37 cm x 55 cm)
Waterford 140 lb. cold press

Since a flower is the main subject of this work, I paid particular attention to the way light shines through the petals and over the various forms. Dramatic lighting, coupled with an up-close perspective, conveys an intimate, almost abstract look at flowers. Light creates pattern, reflects colors, and gives life to the subject, and fairly dark backgrounds provide contrast and drama. I paint around whites, pre-wet areas and let colors mix on the paper. When the right intensity is achieved on the first try, the result is fresh and luminous.

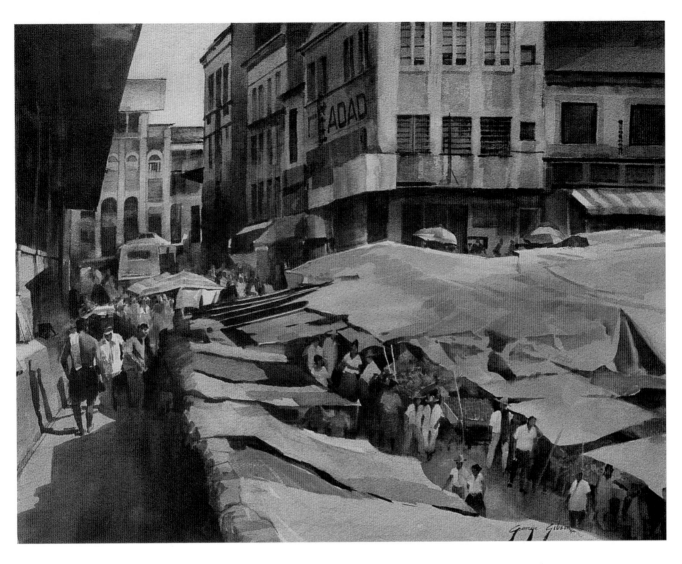

GEORGE GIBSON
Manaus Market
21" x 29" (53 cm x 74 cm)
Arches 300 lb.

Looking down over a canvas-covered market and the inclined street beyond it, the changing elevations of the subject were of particular interest to me. Light and shadow, the shapes they create, and the play of sunlight throughout the composition were an irresistible challenge. The combinations of light and shadow were achieved by close attention to values and textures of the subject.

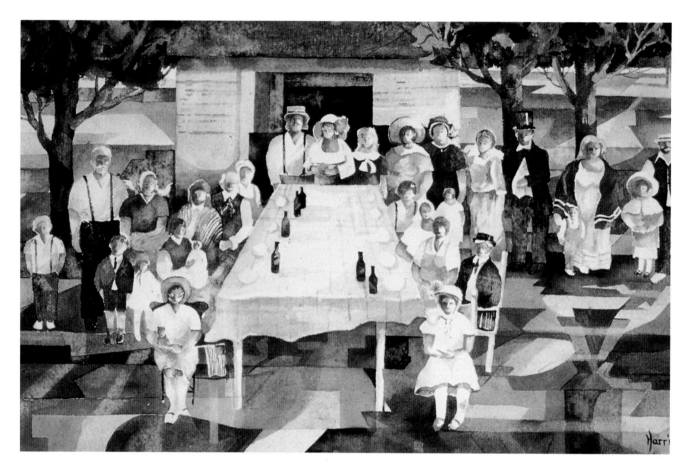

HARRIET ELSON
Mosiac Family
12" x 21" (31 cm x 53 cm)
Arches 300 lb. cold press

Mosaic Family represents the coming together of different pieces to form one entity. The people are painted light and bright with hard edges to strengthen and keep them as one unit. The viewer is brought into the painting with muted light shapes around the group. Light is essential in my paintings to directing and holding the viewer's eye.

GREGORY B. TISDALE
Middletown
17" x 27.5" (43 cm x 69 cm)
Morilla 130 lb.

In *Middletown*, the entire painting is backlit, and shadow serves as the stage of the painting. The painting is done in almost complete shadow with the only direct shadows found on the deck of the ship. The image of the ship on the ice is a reflection, and the streetlights in the foreground fail to cast a shadow as their light is diminished by the coming of the dawn. Other shadows are muted or diffused and are not immediately recognized.

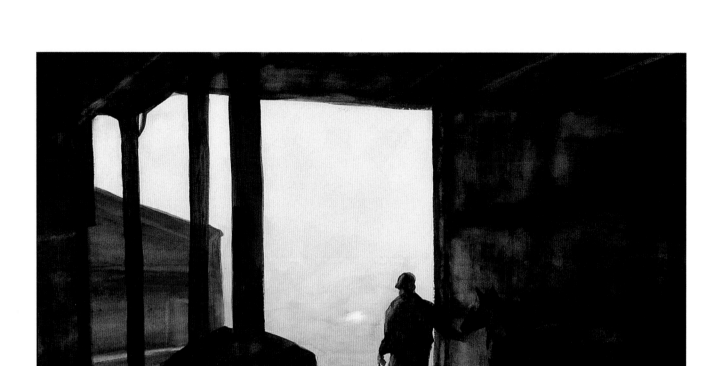

M. C. KANOUSE
Frey's Barn–Morning
17" x 25" (43 cm x 64 cm)
Lanaquarelle 300 lb. cold press

Early-morning sun provides a vivid contrast, giving solid form to the shadowed areas. Strong contrasts between the high values of the sun and the low values of shadow provide drama to the subject's early-morning time frame. The painting was done with many washes from light to dark. Highlights were established in the shadow pattern by partially removing some areas of the dark paint, changing shadow value and providing form.

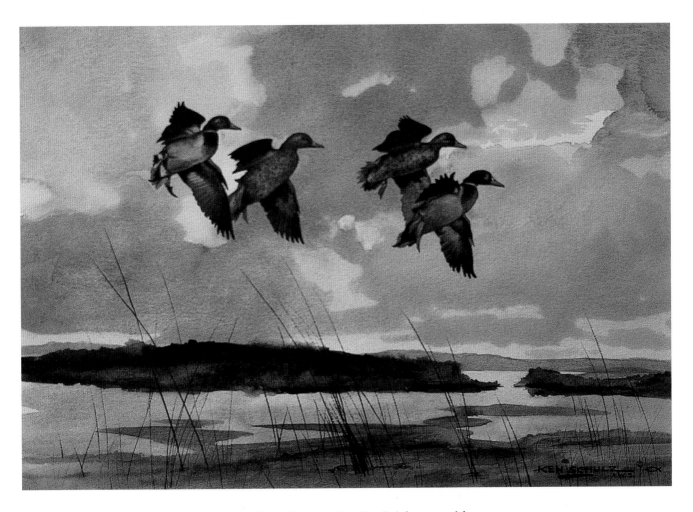

KEN SCHULZ
Two Pair
9" x 12" (23 cm x 31 cm)
Strathmore rough

I chose illustration board for *Two Pair* because of the transparency and smoother texture this board offered. I pursued the dark, medium, and light values that relate to the picture planes of foreground, middle ground, and background. Depth and distance were further enhanced by painting the sky first with light washes and adding clouds with shadow and light afterwards. Following a foreground wash, darks were added to the middle ground and foreground. Feather detail was created using shadow and light.

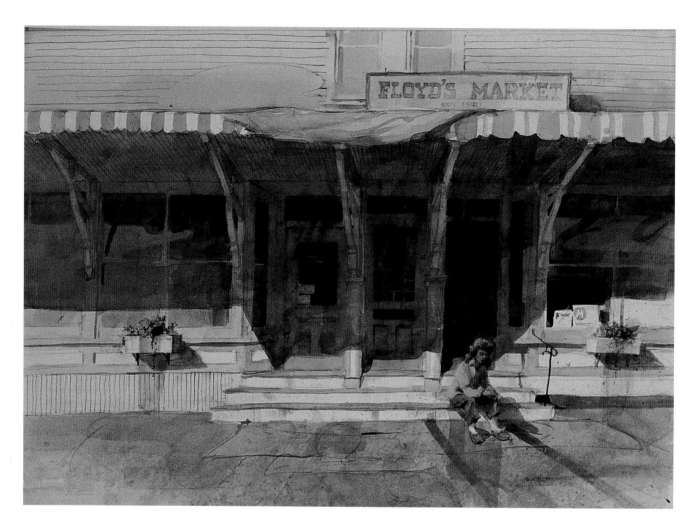

GEORGE J. SHEDD
Waiting at Floyd's
22" x 30" (56 cm x 76 cm)
Bainbridge cold press

The awning over the turn-of-the-century market shadows the window and door beneath while sunlight bathes the steps and the figure to create an interesting value pattern of lights and darks. Working in crisp washes in a light-to-dark sequence, I find that transparent watercolor best conveys the quality I try to achieve, such as the rich, dark colors within the shadows.

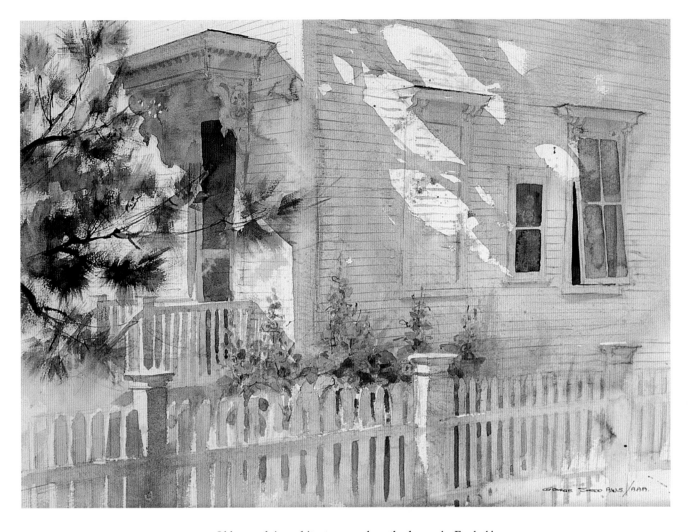

GEORGE J. SHEDD
Fresh Air
22" x 30" (56 cm x 76 cm)
Strathmore 300 lb. cold press

Old, nostalgic architecture, such as the house in *Fresh Air*, always offers interesting shapes as subjects for painting. The play of light and broken shadow across the house creates a diagonal pattern that is filled with nuances of color. The fluid quality of transparent watercolor painted simply and directly makes the reflected light in the shadows glow.

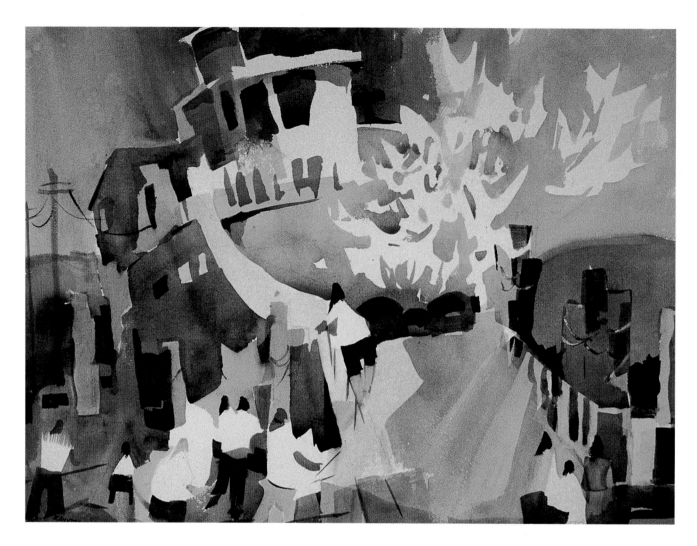

EDWIN C. SHUTTLEWORTH
Gulls at Port Kent
17.5" x 23.5" (45 cm x 60 cm)
Arches 140 lb. cold press

Never hesitating to use ambiguous light sources in my work, I feel the design should always be paramount. My subject choices relate to the energy and light that symbolize energy. Cast shadows are useful in unifying the composition and in *Gulls at Port Kent*, the shadow shape on the boarding ramp forms part of the *S* configuration of the dominant white shape.

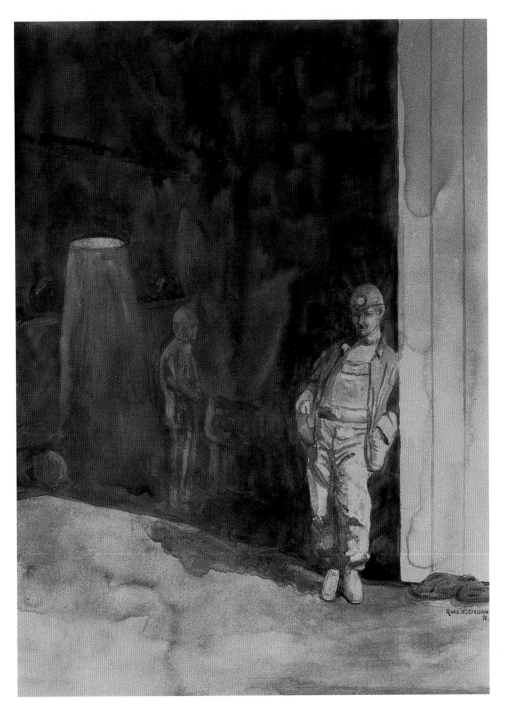

JULE McCLELLAN
2:30 P.M.–Taking a Break
23.5" x 19" (60 cm x 48 cm)
Strathmore illustration board

Collection of Sugar Camp Coal Company

The shadow of the miner directs the viewer into the dark shadows within the building. Gessoed illustration board lets the watercolor create textures; Winsor green, alizarin crimson, and black used in a fluid manner set the stage for the miner as the center of interest. Equipment in the building and the figure in the shadows were achieved by wiping away the images, then repainting where necessary. The miner and coiled rope were painted in a controlled method and the remainder of the painting was done using a loose, watery approach.

NEL BYRD
November
22" x 30" (56 cm x 76 cm)
140 lb. cold press

In creating the composition for *November*, shadows were instrumental in the design and layout. Interesting shapes of the shadow patterns provided the opportunity for color change, reflected light, and values ranging from light-to-dark and warm-to-cool. Elements outside the picture plane were suggested with shadows and in doing so, mundane subjects became unique. Using transparent watercolor, the technique of dropping color into wet wash areas gave me a blend of color and soft edges. I painted on dry paper to achieve sharp edges and saved the white of the paper by painting up to and around the shapes without using any masking.

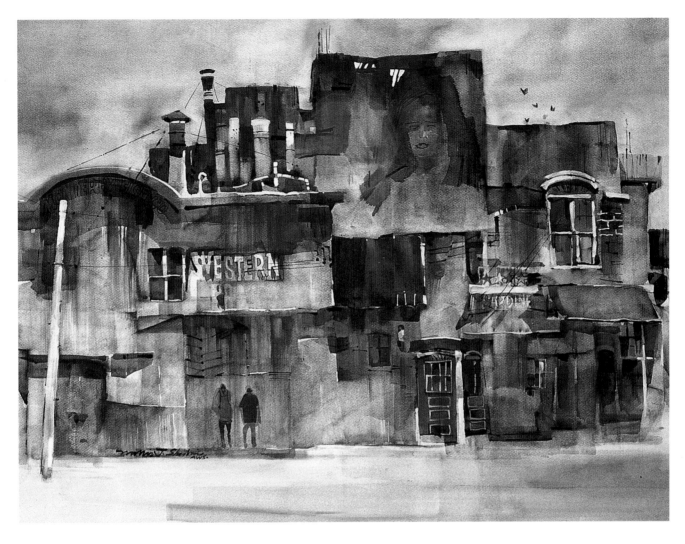

MORRIS J. SHUBIN
Cannery Row
30" x 40" (76 cm x 102 cm)
Strathmore

To create interest, the upper portion of *Cannery Row* was exaggerated and contrasted against the quiet space of the sky. The large facade was painted in warm and cool colors allowing light and heavy washes to flow into wet areas. The process was repeated, and after each wash had dried, a delicate sponging out was used to achieve a luminous effect. Accents of opaque white were applied as highlights and shadows were exaggerated to reflect the surrounding colors.

PAUL W. NIEMIEC, JR.
Seaworthy
21" x 29" (53 cm x 74 cm)
Arches 300 lb. cold press

In *Seaworthy*, I depicted the soft, diffused light of a calm island morning by working with a limited palette of grays painted in closely related values. Layers of transparent washes were built up to achieve the luminosity and atmospheric haze over the scene. The contrast of light and shadow, the incidences of reflected light, and the balance of warm and cool colors were established by using transparent primary colors in sequential glazes. Shadows were developed with washes of cool, complementary violet tones painted over warm, sand-colored accents.

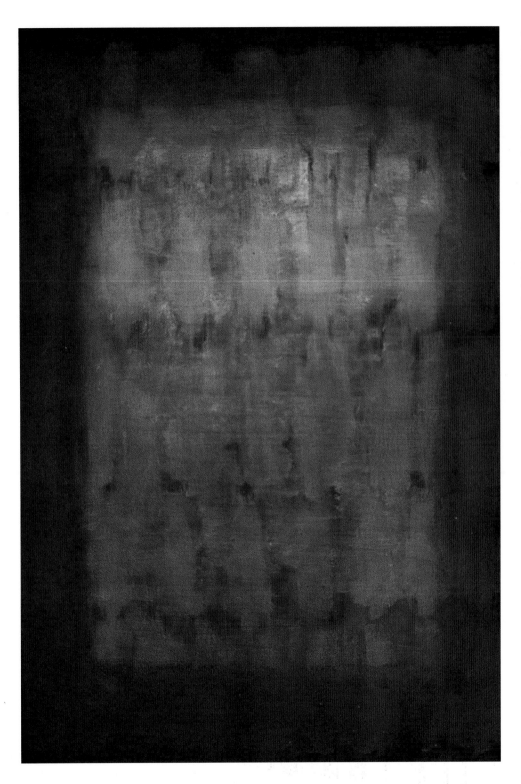

JOHN McIVER
Ceremony 57
29" x 21" (74 cm x 53 cm)
Waterford 140 lb. cold press
Watercolor with acrylic

My main concern in *Ceremony 57* was the suggestion of groups of figures that would result in an abstract overall pattern. Shadow was used in washes of translucent and transparent paint to establish areas of high and low emphasis. I used a layering of washes, including white, to build texture. Shadow was important to achieve a simplified pattern.

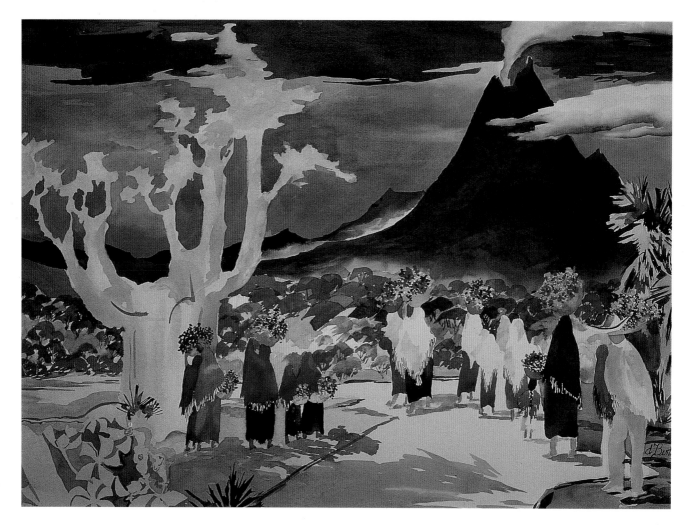

DOROTHY W. BERTINE
Colima Flower Gatherers
22" x 30" (56 cm x 76 cm)
Arches 140 lb. cold press

Shadows play an important role in the creation of interesting positive and negative shapes within a composition. They define forms with irregular edges and textural richness, and increase the luminosity of colors. Furthermore, shadows define the direction of the light, time of day, and weather conditions. I find a painting that is at least 75% shadow much more exciting than a painting representing full light.

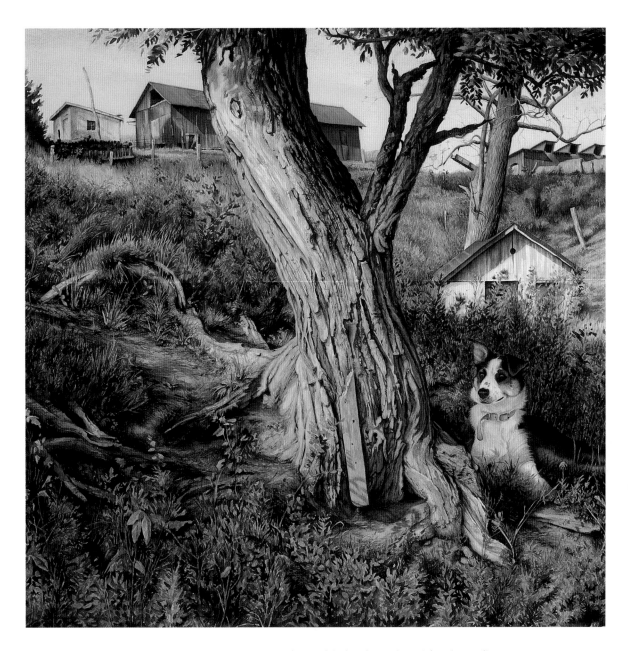

DANIEL J. MARSULA
Sanctuary
26" x 26.75" (66 cm x 68 cm)
Arches 140 lb. cold press

In *Sanctuary*, the total feel and emotion of the piece relies on shadows to carry the viewer through the composition. The organic shapes and colors found in nature are my subject of preference. Nature, with its endless supply of shapes and shadows, is best expressed through watercolor and the many techniques available. I've used a combination of drybrush, wet-in-wet, and repeatedly glazed-over transparent washes to create the desired effect.

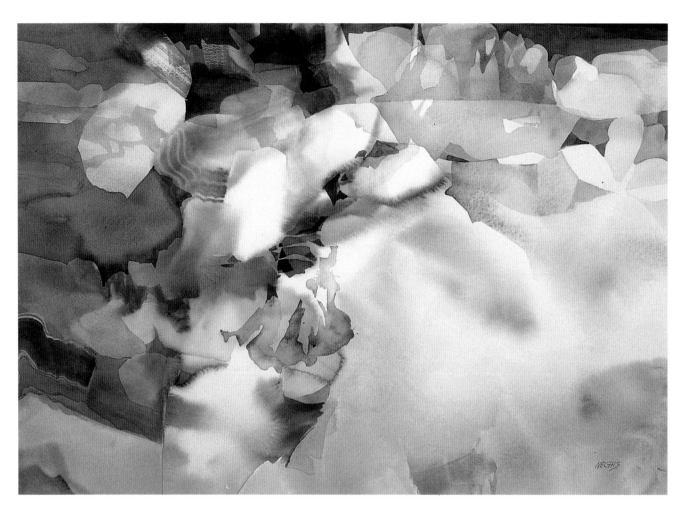

BARBARA NECHIS
Lunar Series: Moon in Scorpio
22" x 30" (56 cm x 76 cm)
Arches 140 lb. cold press

Without plan or direction, I began this painting by experimenting with shapes. Moonlight came to mind as I added layers of transparent washes that pulled together my numerous initial shapes. Preferring the mood created by close value chords, I used repeated washes to subdue contrasts and excessive light and found that this technique gave the remaining lights a lunar quality. Although negative painting is essential in defining light, I added pattern to the large rock shape at the upper left to prevent a void.

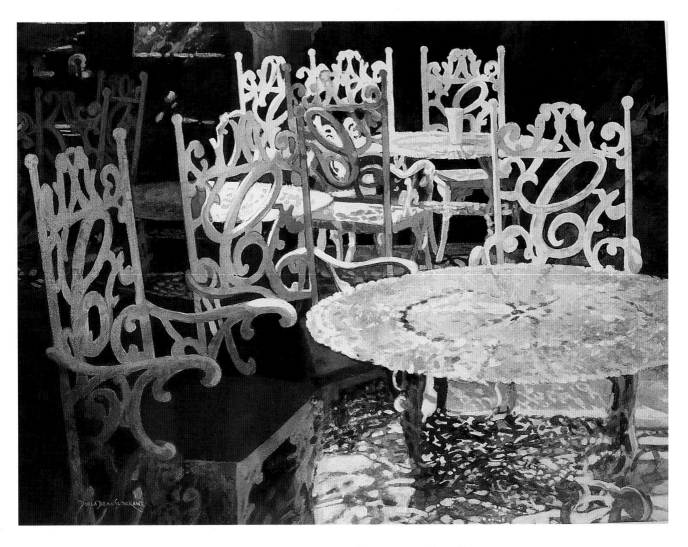

DORLA DEAN SLIDER
Waiting Tables
18.75" x 26.25" (48 cm x 67 cm)
Arches 300 lb.
Watercolor with acrylic and watercolor
pencil

The stark, almost black-and-white pattern of the tables
and chairs against the sharp shadow created by the high
noon sun inspired me to paint *Waiting Tables*. I gessoed
the paper as my base to create the texture of the wrought
iron. Using a liquid mask on the background tables and
chairs, I applied a medium dark wash across the shadow
area. I then masked the foreground shadow chair and
applied a darker wash, balancing warm and cool and
adding the lights last. Touches of watercolor pencils
added finishing accents.

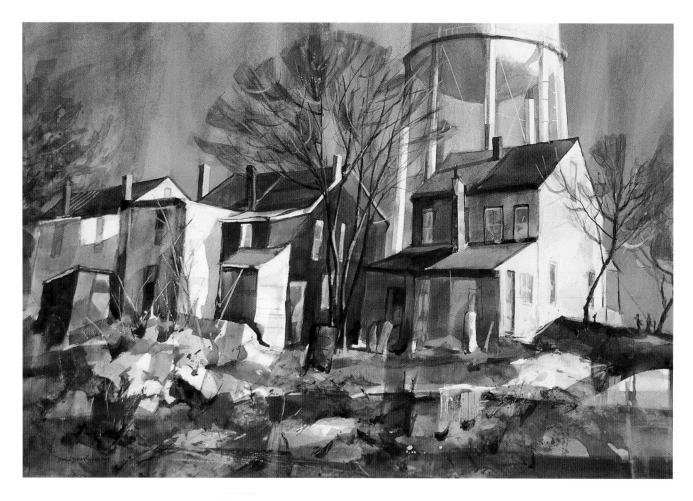

DORLA DEAN SLIDER
Sheridan Street
17.5" x 25.5" (44 cm x 65 cm)
Illustration board

The visual power of the water tower over the stark buildings was the inspiration for *Sheridan Street*. The tower and rooftops were masked with a tape that doesn't mar the paper's surface. After first trying a lighter sky wash, I used a darker wash in large vertical strokes to make the sky more dramatic. I played up the rock forms and melted snow on the ground to balance the white areas. Rag illustration board was chosen for its smooth surface that lifts easily, allowing me to work faster and create my own textures.

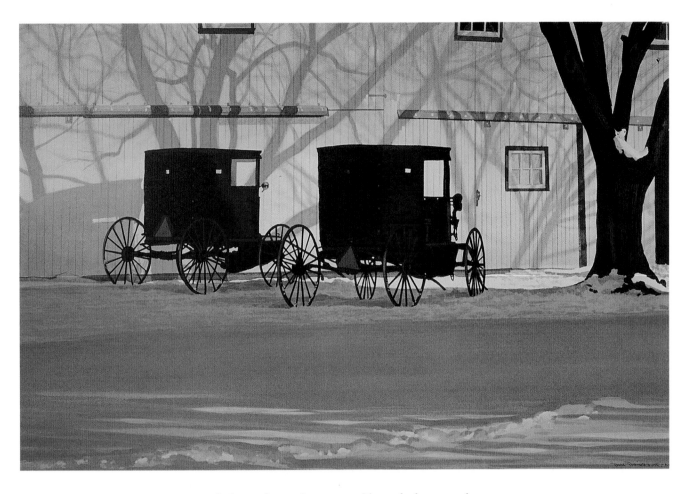

DONALD W. PATTERSON
Two of a Kind
17" x 26" (43 cm x 66 cm)
Arches 300 lb. cold press
Watercolor with gouache

An integral part of my compositions, shadows are often what draw my attention to a subject. I prefer to paint subjects bathed in late afternoon sun, when the shadows are most exciting. The play of shadows falling on the barn and across the foreground in *Two of a Kind* brings visual appeal to the work. I painted thin washes of opaque white and blue gouache over transparent watercolor to arrive at the precise color and value desired.

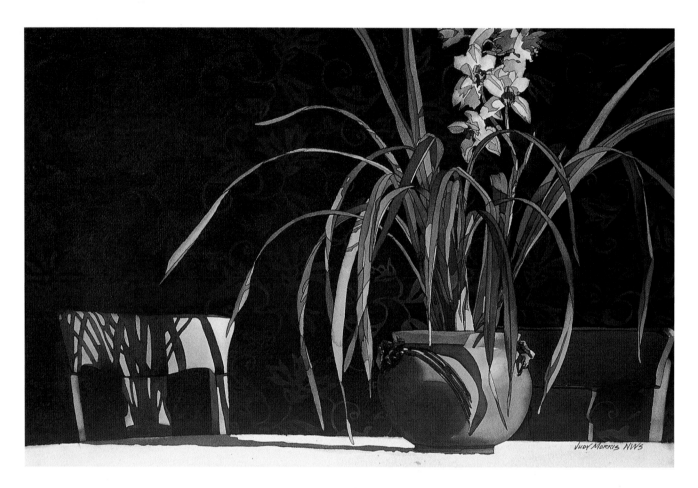

JUDY MORRIS
Aunt Edna's Roseville Vase
21" x 29" (53 cm x 74 cm)
Arches 300 lb. cold press
Watercolor with ink

Flowers on my dining-room table are often subjects for my watercolors because I love to paint the vases I collect, and the early-morning light of January creates breathtaking shadows. The background reads as one dark area even though an invented pattern painted in the same value of other colors actually makes up the background shape. This contrasts sharply against the white tablecloth where I've implied lace by painting only a few of shadows. By painting the chair on the right in almost total shadow, I've emphasized the importance of the shadow pattern on the other chair.

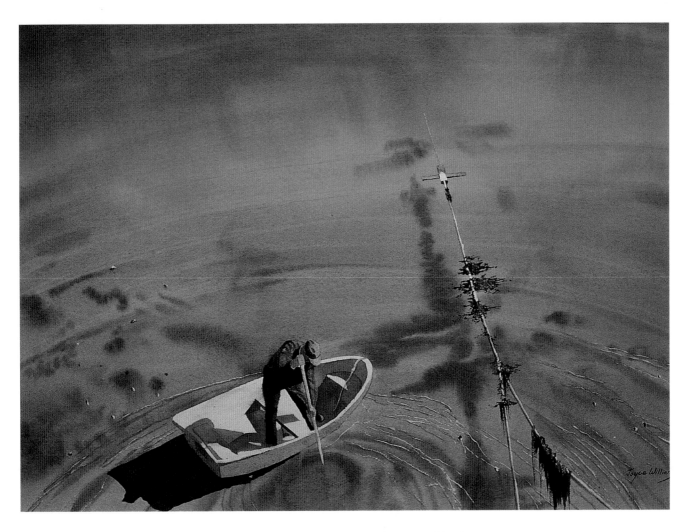

JOYCE WILLIAMS
Whirlpool
22" x 30" (56 cm x 76 cm)
Arches 300 lb. cold press
Watercolor with acrylic

Shadows are very much a part of the composition in *Whirlpool*, with the shadow of the haul line being particularly important. The subject, an older lobsterman, was chosen because of his interesting perspective. I used a limited palette of blues and yellows and painted primarily with transparent watercolor and used some acrylic to achieve the texture of the sandy area of the water.

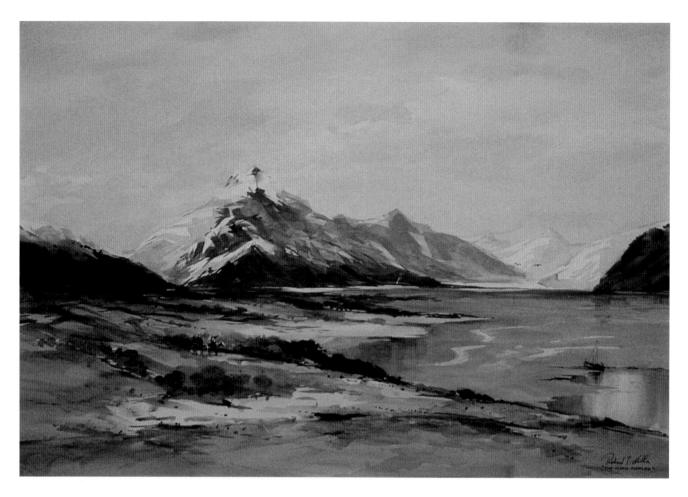

ROBERT T. MILLER
The Cloud Piercer
20" x 31" (51 cm x 79 cm)
Strathmore 114 cold press
Watercolor with acrylic

This subject, located in New Zealand, includes a full range of tonal values. The snow-covered areas of the mountains are contrasted with the deep shadow areas. The cool darks are complemented by the closer mountains painted in warm colors. This very dramatic scene has been captured by carefully contrasting the shadowed areas with the lighted areas.

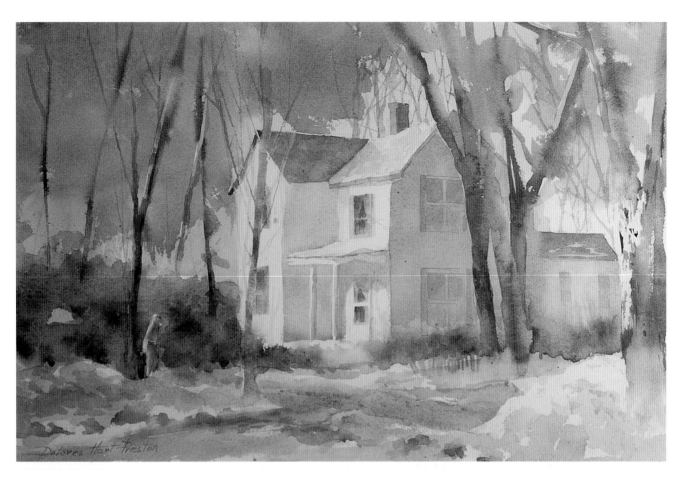

DOLORES V. PRESTON
Coming Home
19" x 22" (48 cm x 56 cm)
Arches 140 lb. cold press

Winter can be cold, drab, and daunting, but when the sun shines on newly fallen snow, beautiful rainbows appear in the shadows. The transparency of watercolor gives color and sparkle to the shadows. *Coming Home* is made up primarily of these shadows, which enabled me to use color in a winter painting.

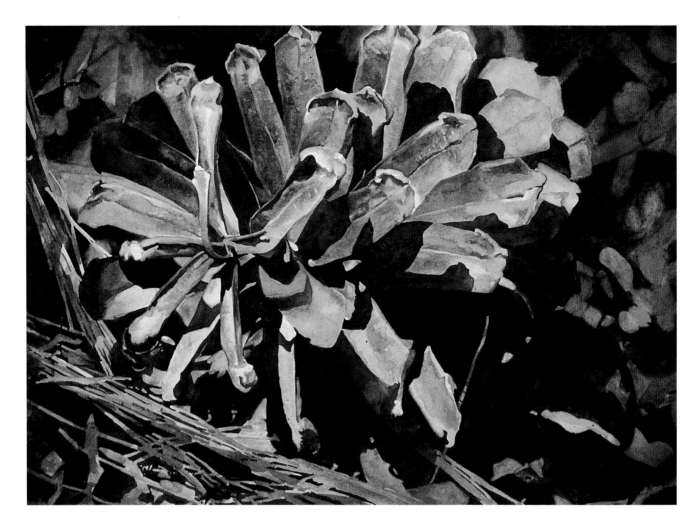

ANGELA BRADBURN
Light Play
21.5" x 29.5" (55 cm x 75 cm)
Arches 140 lb. hot press

Light Play is one in a series of paintings from a close, larger-than-life perspective that depends on light and shadow. The subject was chosen because of the impact created by the strong contrast of lights and darks and my goal was to have as much variety as possible while maintaining unity. Since the shadow areas were so dark, I was able to use rich color in the light areas and hold the light-struck look. Contrasting relationships such as light and dark, cool and warm, transparent and opaque, hard edge and soft edge, and representational and abstract were used to achieve variety.

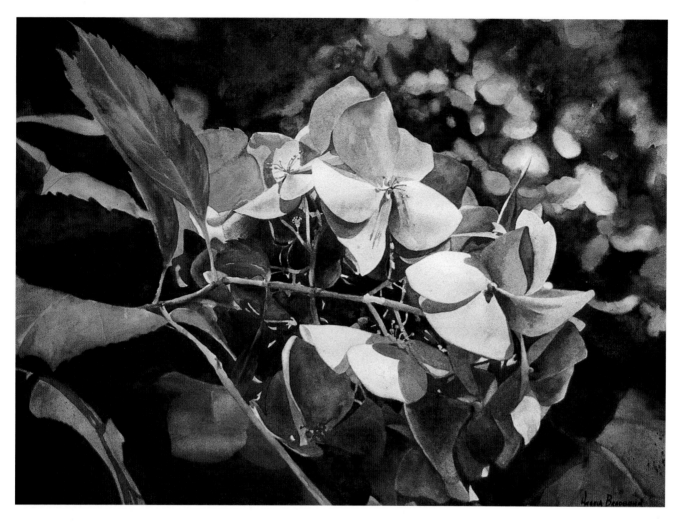

ANGELA BRADBURN
A Closer Look
21.5" x 29.5" (55 cm x 75 cm)
Arches 140 lb. hot press

The subject of *A Closer Look* was chosen because of the strong contrast of lights and darks. Transparent water-color proved perfect for describing the fragile petals in bright light and charging the shadows with rich, saturated, wet pigment. I painted around the light and used lifting to create a subtle quality and unique color. I used a variety of edges, from crisp to soft to blurred. Shadows define the shapes and contours of the petals and leaves, but also create abstract shapes that dance across the paper.

DOUGLAS WILTRAUT
Family Man
56" x 36" (142 cm x 91 cm)
Arches 114 lb. rough

Family Man is a portrait of my father
as he stands in the shadow of the
house he built himself. Contrasts were
exaggerated in order to bring out sun-
light; this was achieved by darkening
the shadow so the sunlit part of the
subject could be filled with color. The
English method of watercolor was used
for the colors of the skin, creating a
pastel effect similar to the softness of
older skin. An elongated diagonal
shadow was used to define the
musculature of the figure.

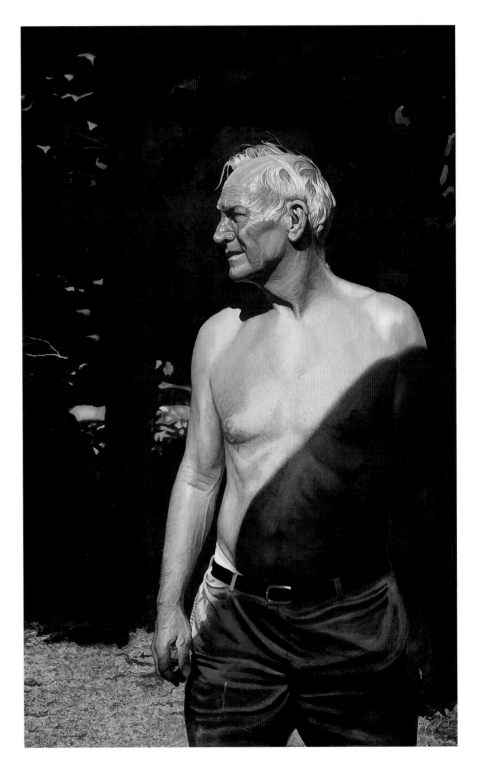

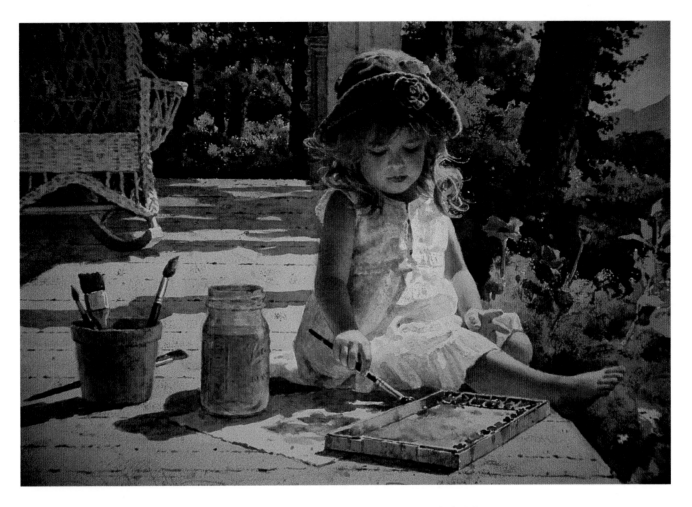

JOSEPH BOHLER
Rebecca Painting
21.5" x 29.5" (55 cm x 75 cm)
Arches 300 lb. cold press

The essence of this painting is the natural sunlight falling on my granddaughter Rebecca, casting shadows on the porch. I painted the values around her dark enough to enhance and intensify the light that was reflecting off of her. I used a large 1.5-inch brush for the large shapes in the background and foreground. The figure was painted with a large round brush, glazing several times over the flesh tones to maintain a softness. Spatter was used on the porch and drybrush on the trees and grass.

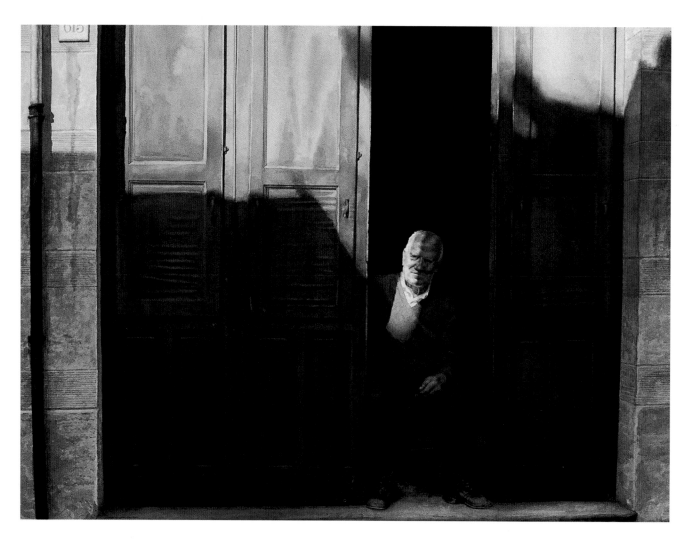

MICHAEL P. ROCCO
Paesano
21" x 29" (53 cm x 74 cm)
Arches 140 lb. cold press

The shadow in *Paesano* is the unifying and dramatic element of the composition, accentuating the man's face and body. I use strong shadow and light to bring an aspect of dimension, spatial relationship, and the feeling of chiaroscuro to my work. For this painting, I established the major values working around the figure, establishing light and form. I finished by drybrushing texture into the concrete, wood, and flesh.

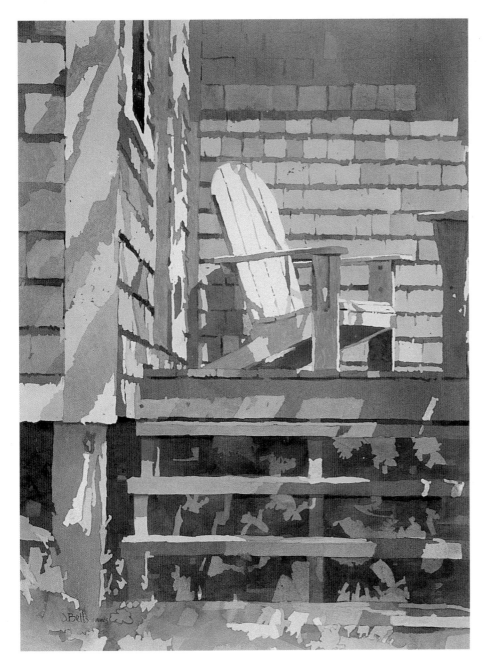

JUDI BETTS
Leisure Landing
30" x 22" (76 cm x 56 cm)
Arches 140 lb. cold press

I was prompted to paint this picture by the exciting shadows, rich textures, and strong value patterns that made the Adirondack chair appear luminous. In order to convey those visual qualities in my watercolor, I emphasized the shadows around the chair and the linear, dark mid-tone shadows cast by the shingles. I changed the colors as I moved across the page, using gray tones to make the nearby colors more exciting. I varied the shadows in the upper left by using less texture. Deep in the foliage are diagonal light and dark shapes that accent contrasts.

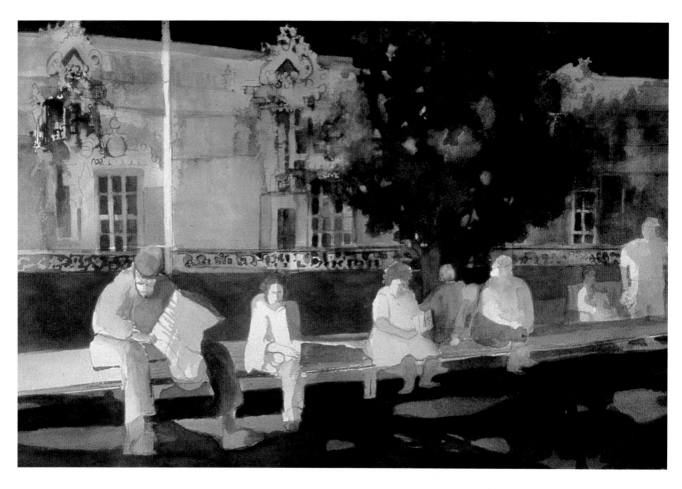

PAT KOCHAN
Bus Stop I
22" x 30" (56 cm x 76 cm)
Arches 140 lb. cold press

The figures in *Bus Stop I* are linked by light and shadow, creating a feeling of solitude that simultaneously shares the existing space. The figures are gradated from light to dark to give them form, and the shadow shapes are kept simple and flat to link the figures and move the viewer's eye across the page. For the shadow areas in the sky, tree, and ground, I layered one glaze of complementary color over another to achieve a rich, deep value of underlying color. For the building, I layered color on color to build each small shape, then covered the large areas with light washes to add depth to the background.

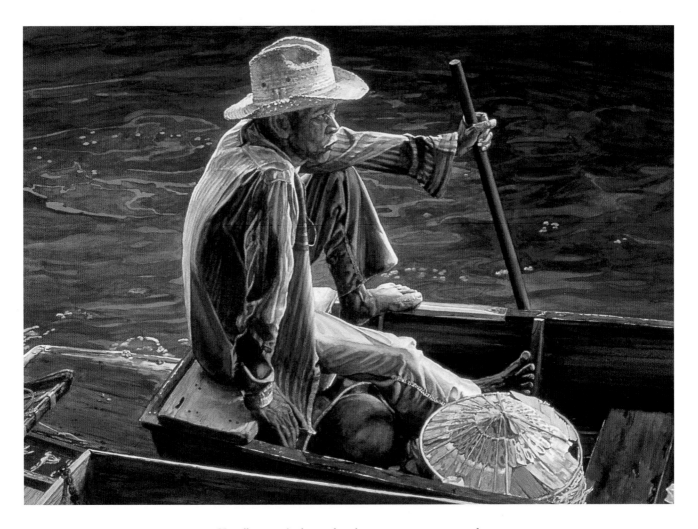

EDWIN L. JOHNSON
Old Fisherman
17" x 27" (43 cm x 69 cm)
Strathmore 100% rag

Usually an artist has only a few moments to capture the viewer's interest. Composition, light, and shadow are paramount to achieving this—with color and detail prolonging the moment. In *Old Fisherman*, the figure is played against the dark of the water with the highlights describing his relaxed attitude. The high backlighting gives the work a sense of drama that makes the painting exciting. Working exclusively in transparent watercolor without any masking materials or opaques, I try to create an interesting arrangement of forms by painting whatever challenges me.

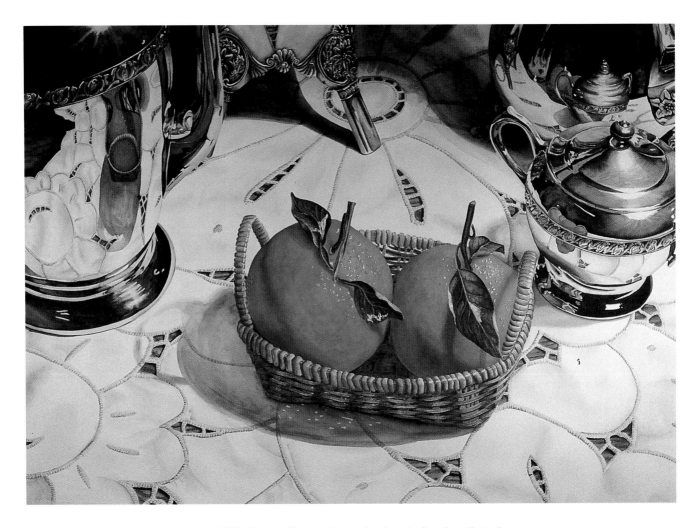

BRAD DIDDAMS
Tight Squeeze II
29.5" x 40" (75 cm x 102 cm)
Arches 555 lb. cold press

Tight Squeeze II is one in a series that studies the effect of light on reflective and semitransparent objects. The coffee pots were chosen to reflect the table and objects on it, and the sugar bowl helps reflect the light source. The set-up was done in a dark room with a single light controlled to fade from one edge of the image to the other. I then photographed the set-up and worked from photographs. While painting, much attention was paid to the highlights to emphasize the structure and add sparkle to the work.

AMANDA JANE HYATT
Melbourne Town Hall
35.5" x 27.5" (90 cm x 70 cm)
Arches 300 g. cold press

With *Melbourne Town Hall*, I created an image of light filtering through the large tree at the right onto the people and reflecting off the building. The subject was chosen for the beauty, solidity, and grandeur of the building compared to the smallness of the people passing by it. Shade under the portico was kept light to show light reflecting off different surfaces. Watercolor easily allows the comparison of light and shadow to be made, the light being the whiteness of the paper or the transparency of the paint. Capturing the light gives a painting magic and a establishes the time frame.

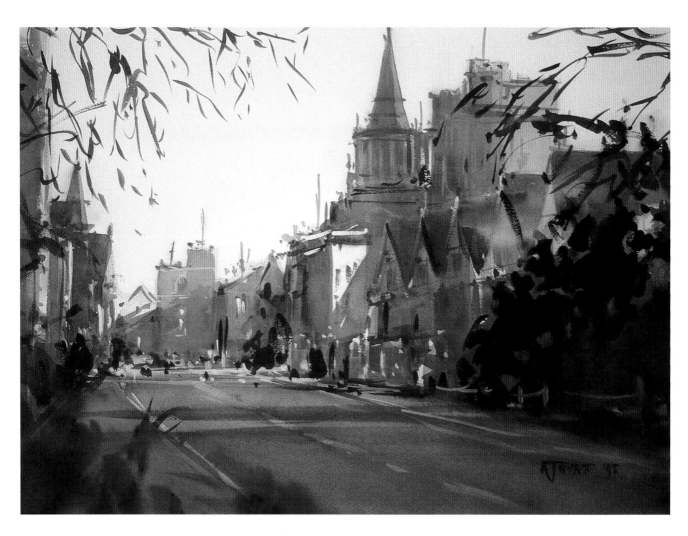

AMANDA JANE HYATT
The High—Oxford, U. K.
35.5" x 27.5" (90 cm x 70 cm)
Arches 300 g. cold press

In *The High–Oxford, U. K.*, I tried to recreate the subtle shade that often dominates an English scene. The details on the buildings were played down and the washes were not fully transparent. An opaqueness, rather than a darkness, was sought to give the impression of a cold, smoky late afternoon. This was achieved by painting the buildings and foreground with up to three washes, then highlighting the dark keyhole shadows with a strong mixture of ultramarine blue, burnt umber, and violet.

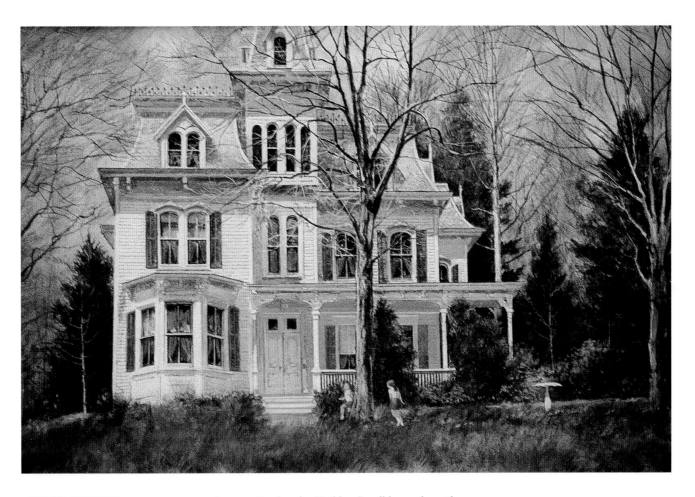

GEORGE SOTTUNG
Victoriana
14.5" x 20" (37 cm x 71 cm)
Bainbridge board

I apprenticed under Haddon Sundblom, whose theory was light in all its aspects. His technique was secondary to his awareness of light and shadow and sun-drenched color. In *Victoriana*, I waited for the early afternoon light to warm the colors to the high-keyed palette of the Impressionists. Extraordinary shafts of light break through the picturesque old house and emanate outward. This radiant building, with its high-pitched roof and brilliant windows, is one of the most beautiful along the road.

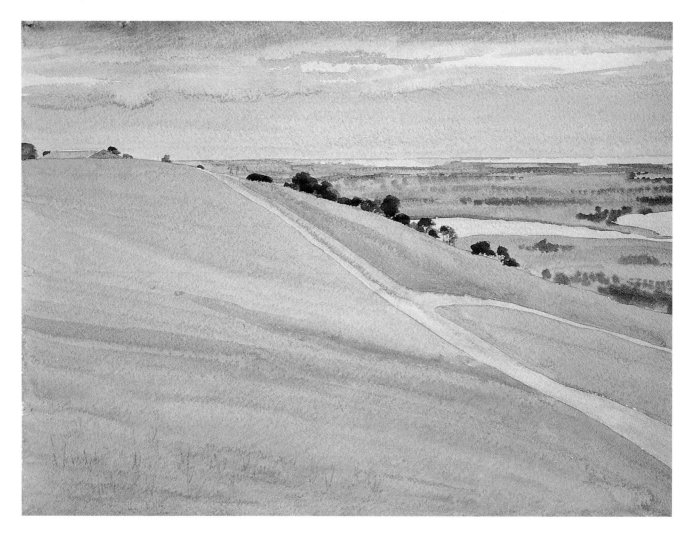

CORALIE ARMSTRONG
Murray Mouth, South Australia
22" x 29" (56 cm x 74 cm)
Fabriano 600 gsm rough

Light is very important in my painting, both in choice of subject and manner of painting. Colors and tones are affected by light intensity, and the strong Australian sun can drain color. Transparent watercolor allows the light from the paper to show through and is best achieved by a single wash of color. In this painting, the clear distance appealed to me, along with the shapes of the water, hillside, and road. The heavy, rough Fabriano paper provided an interesting texture.

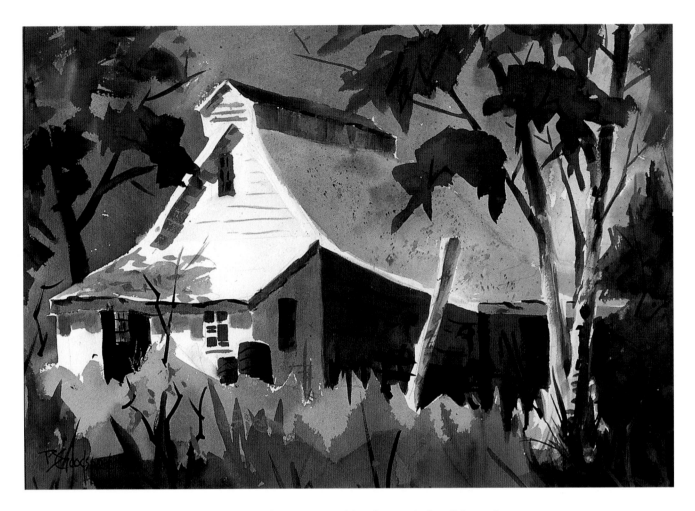

BARBARA GOODSPEED
Sugar House
15" x 22" (38 cm x 56 cm)
Arches 140 lb. cold press

As one of the most essential tools an artist has, light establishes our patterns, values, textures, all the design principles, as well as the mood of the painting. For *Sugar House*, I felt the light source was what would enhance the work and provide a focal point. The sugar house had a good shape, and by changing its color from gray to white, I was able to create spots of light, color, texture, and shadow to compose an interesting painting.

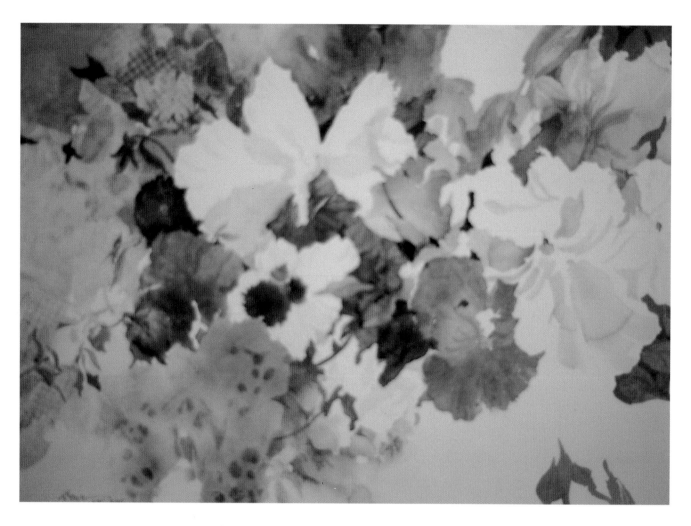

PAT DEWS
Pansies with Grid
21" x 29.5" (53 cm x 75 cm)
Rives BFK
Watercolor with ink and acrylic

This painting is a composite of pansies from numerous photo studies. Flowers are translucent and lend themselves to the subject of light. Using the white of the paper for the dazzling white pansies, I allowed the white to flow from positive to negative spaces without stopping, creating visual contrast and excitement. Small areas of white paper served as areas of light that moved throughout the painting. Good value contrast and strategic darks next to the whites made the whites stand out.

KITTY WAYBRIGHT
Old Shay Drivers
19" x 29" (48 cm x 74 cm)
Arches 300 lb.

A strong light and shadow pattern allows me to see and feel a subject regardless of its actual form. Without light, *Old Shay Drivers* would be flat, and have no life, power, or rhythm. In my drawing, I emphasized shadows, letting their shapes build up form. Similar to working a giant puzzle, I started first with shadows that were done very lightly, and once basic shapes were established, it was push and pull all over the paper, building darks by glazing layers of color.

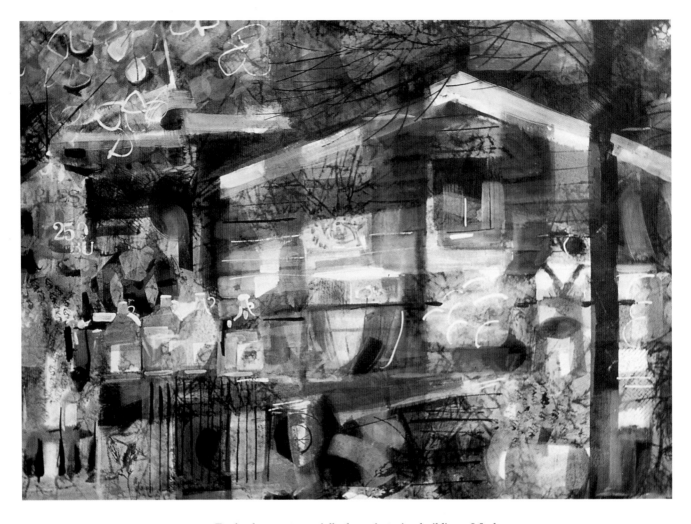

JANE OLIVER
Autumn Stand
25" x 30" (64 cm x 76 cm)
140 lb. hot press

For landscapes, especially those featuring buildings, I find that shadows help enliven a watercolor. Shadows also give the subject a three-dimensional aspect. In *Autumn Stand*, the jugs of cider, baskets of apples, and pumpkins in the foreground are defined by the light and shadow. I used a wet-in-wet technique and after drying, I glazed transparent layers of color.

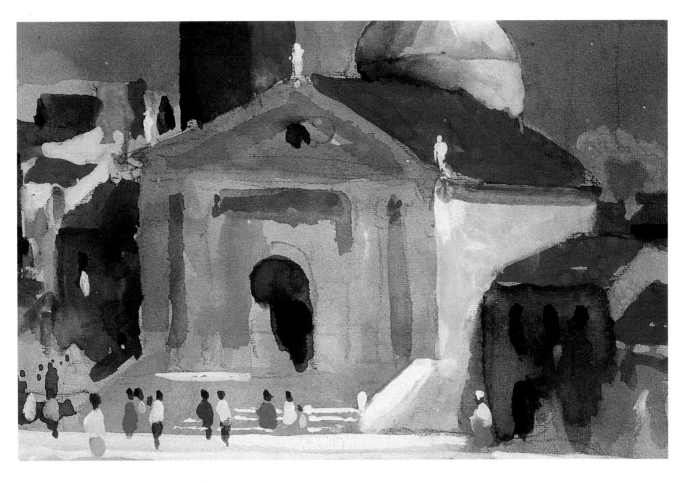

DON O'NEILL
Church Along the Canal—Venice
6" x 7.5" (15 cm x 19 cm)
Bockingford 140 lb. cold press
Watercolor and gouache

In *Church Along the Canal—Venice*, I chose a subject that could demonstrate light and shade relationships. Light was all important, so the rich, dark shadow passages were used to accent it. Placing light warm passages adjacent to the cool darks added excitement to the work. The main light area in the painting was established to provide a resting place for the viewer's eye amongst the primary activity that is focused there.

ALICE A. NICHOLS
The Red Chair
28.5" x 21" (72 cm x 53 cm)
Morilla 140 lb.

While traveling in Key West, Florida, I came upon this image of a red chair through an open window. The play of shapes and the contrast of dark against white, the red chair against the green shutters and the white walls was so simple, yet so complex. I applied layers of paint over each area, allowing each to dry, until the strength of contrast I desired was achieved.

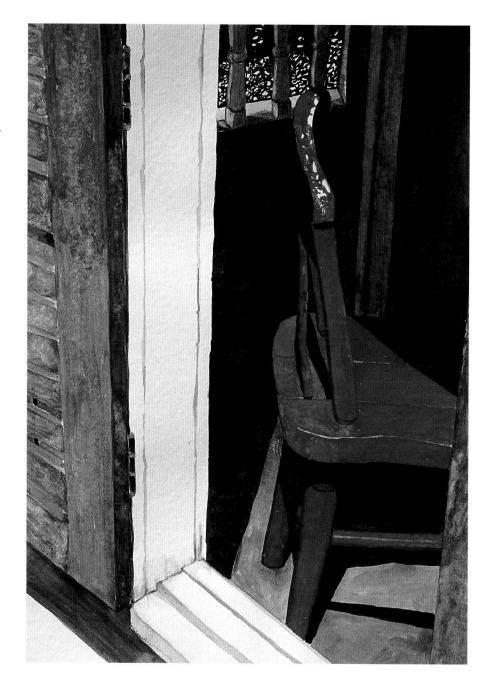

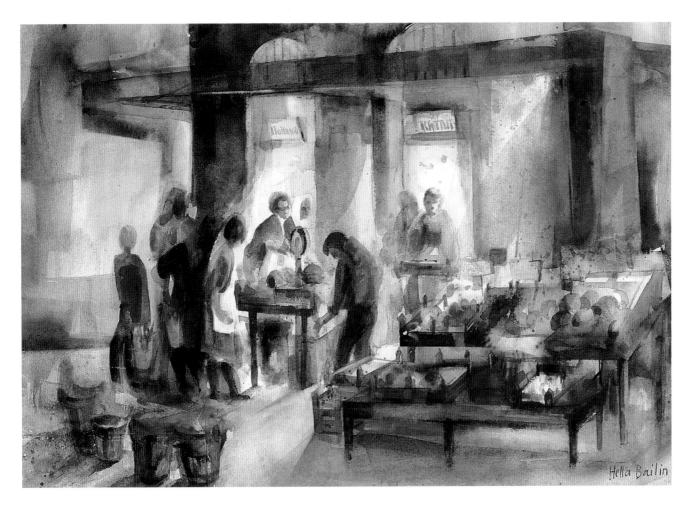

HELLA BAILIN
Night Market
28" x 36" (71 cm x 91 cm)
Whatman 90 lb. cold press

Inspired by warm, transparent lights contrasted with the darker, cool shadows, *Night Market* was created from sketches made in Hydra, Greece. Bright colors on the figures and wares were accented against the cool background. The background was painted wet-in-wet, leaving some of the white paper to create highlights. After the paper dried, the figures and detail were applied.

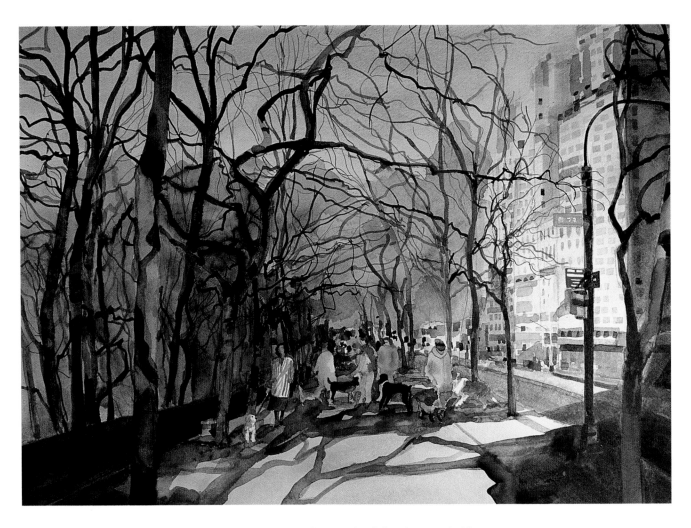

JANET POPPE
Morning Walk
28" x 36" (71 cm x 91 cm)
Fabriano 140 lb. rough

Seeking to capture the morning light of autumn in New York City, I played light and dark shadow forms on the moving people and dogs to create a center of interest. Working with a limited palette, the rough surface paper allowed the paint to settle into the many crevices, which added extra color density and sparkle. The paint was applied wet-in-wet in bold strokes, leaving a good amount of white paper and continually working the entire surface in detail and texture.

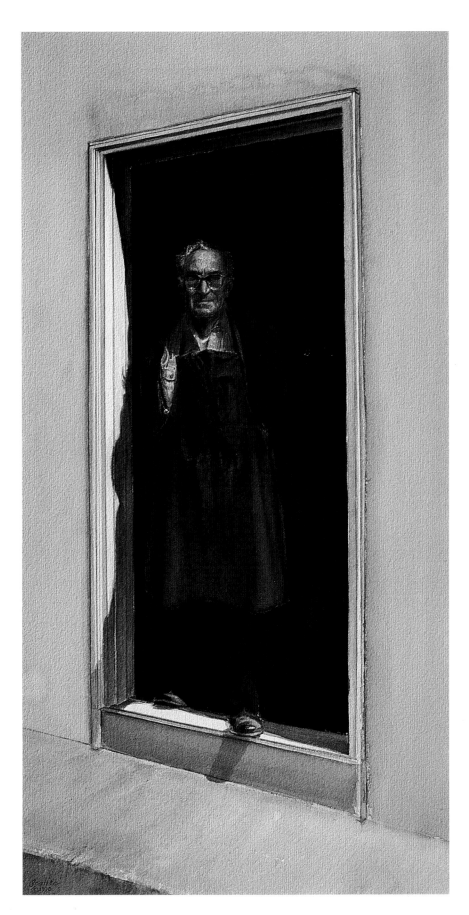

NICOLAS P. SCALISE
John in Doorway–Meriden, CT
30" x 16" (76 cm x 41 cm)
Arches 140 lb. cold press

I look for an emotional response in choosing a subject matter. John, the shoemaker, emerges from the darkened doorway and waits with anticipation for customers. Shadow plays a major role in setting the mood and becomes the unique aspect of the painting. My disciplined approach starts with compositional studies, followed with careful drawings, and then a build-up of layers of paint.

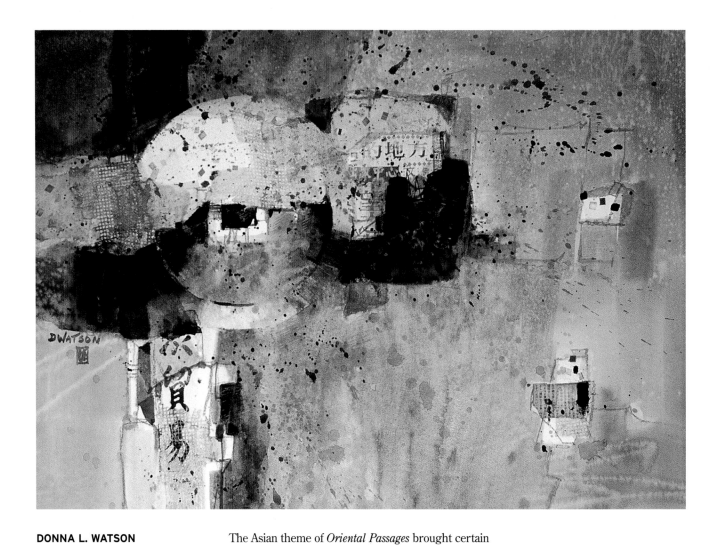

DONNA L. WATSON
Oriental Passages
20" x 26" (51 cm x 66 cm)
Crescent hot press
Watercolor with gouache, crayon,
and collage

The Asian theme of *Oriental Passages* brought certain words to mind—harmony, balance, and mystery. With shadow supplying the mystery as well as the balance to my paintings, I try to further balance light or quiet areas and passages with dark shapes and textures. Although I use a number of aqueous media in my work, usually my shadow areas are done with transparent watercolors.

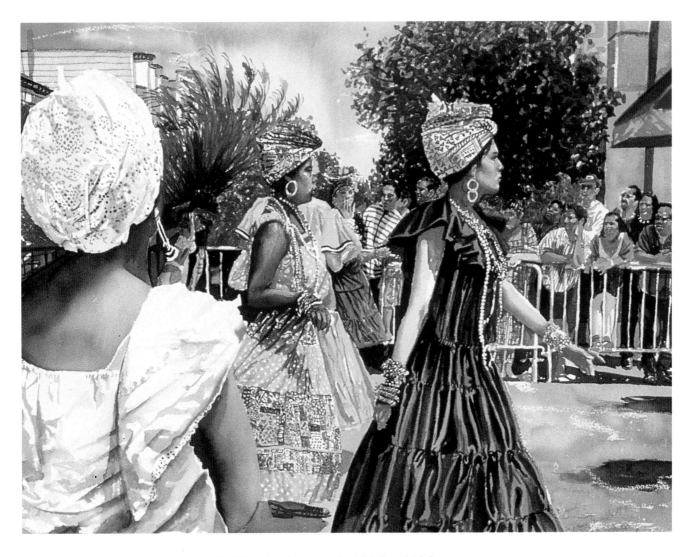

JAMES J. GLEESON
Carnival
25" x 30" (63 cm x 76 cm)
Arches 140 lb. rough

San Francisco has a wonderful light, which becomes clearer and stronger as the year progresses. *Carnival* was painted in October when the light is optimum. The sharp clear light mixed well with the dancers and their costumes, and the shadows were sharp and clear as well, creating a perfect pattern for a successful painting. I established value relationships early in the painting with very dark washes, often leaving them as they are to prevent over-working any one area of the painting.

DOTTIE BURTON
Woman of Yugo
21.5" x 15.5" (55 cm x 39 cm)
Arches 140 lb.

Light was used to project the figure
and was necessary for the composi-
tional design of the painting, leading
the viewer into, around, and out of
the painting. My chosen colors were
indicative of the feeling of the char-
acter and the somberness of the
country and people of Yugoslavia
before war broke out. The play of
light on the figure and pigeons
establishes interest within the work.

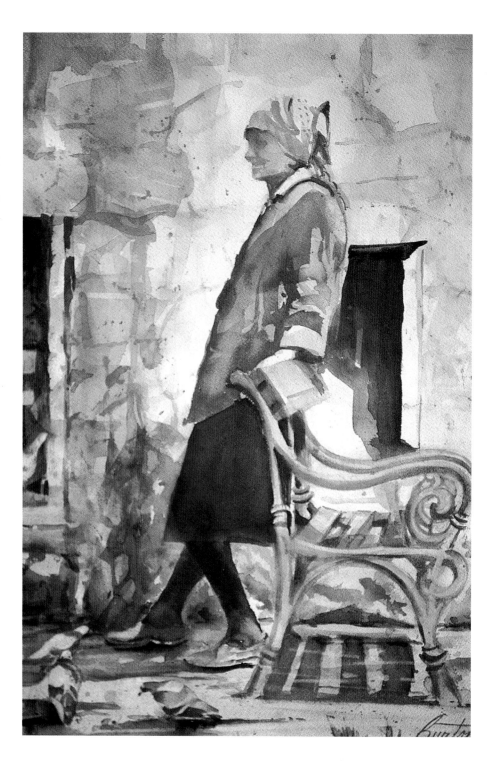

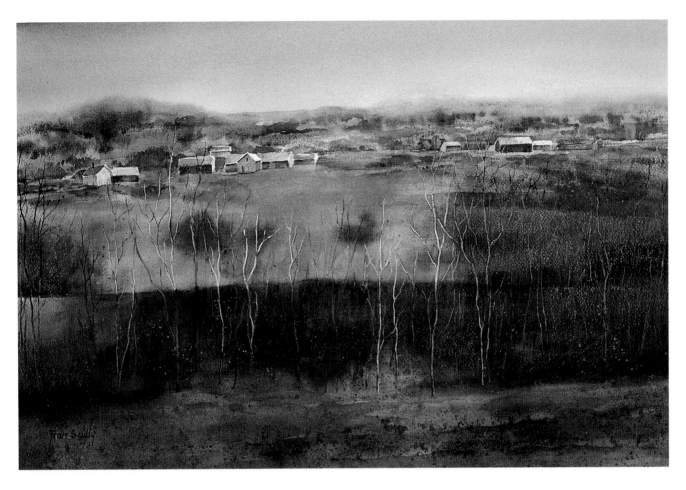

FRAN SCULLY
Afternoon Shadows
14.25" x 21.5" (36 cm x 55 cm)
Arches 140 lb. cold press
Watercolor with gouache

I was attracted to this scene by the horizontal band of shadows crossing the landscape. I visualized the painting using four bands of color crossing the paper, one for the sky, another for the distant hills, a band of dark shadows for the valley, and one for the lighter shadow of the roadside. Using transparent watercolor, I began wet-in-wet, gradually building up color and spattering to create texture. Additional color was included by dry glazing, with more texture added using drybrush and further spattering. Gouache was used for the thin lines of the foreground trees.

LINDA BACON
Eleven Eyes Have It
56" x 42" (142 cm x 107 cm)
Arches 140 lb. cold press

My main criteria for selecting or
rejecting objects in a still life is the
way light plays off and among them.
Shiny reflective objects, translucent
ones, objects that cast dramatic
shadows, and objects that make
striking reflections in other objects
are my primary choices. I arrange
and rearrange the objects with
respect to the light source and each
other. I experiment by shifting the
light source and point of view, but
usually use a single light source
from the side for the most exciting
shadows and highlights. Two-
dimensional shapes take on the illu-
sion of three-dimensional forms by
combining light and shadow and
exaggerating both.

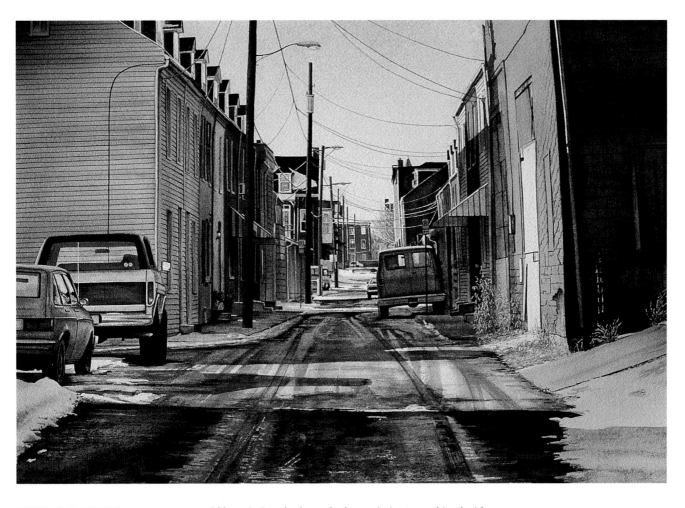

RICHARD P. RESSEL
Lake Street
21" x 28" (53 cm x 71 cm)
Fabriano 300 lb. cold press
Watercolor with acrylic

I like painting the long shadows of winter combined with the shafts of light created by the breaks between buildings. Snow makes an everyday subject extraordinary—streets become a combination of frozen, wet, and dry surfaces which, when combined with shadows, bring interest to the painting. The challenge is to create dimension in the shadows, preventing them from becoming flat. I use acrylics in a transparent watercolor technique, slowly building cool washes to create depth. The permanence of acrylics allows me to build layers of washes, including wet-in-wet, without disturbing previous applications.

HENRY FUKUHARA
Could It Be Mexico?
24" x 18" (61 cm x 46 cm)
Winsor and Newton 140 lb.

Each time I've visited Mexico, I have been excited by the churches, walls, and people. There is a certain quality to the light that permeates the scene that is gloriously depicted with watercolor on paper. This is my interpretation of capturing that light, and in doing so, asking *Could It Be Mexico?* After doing value sketches, I painted directly on dry paper.

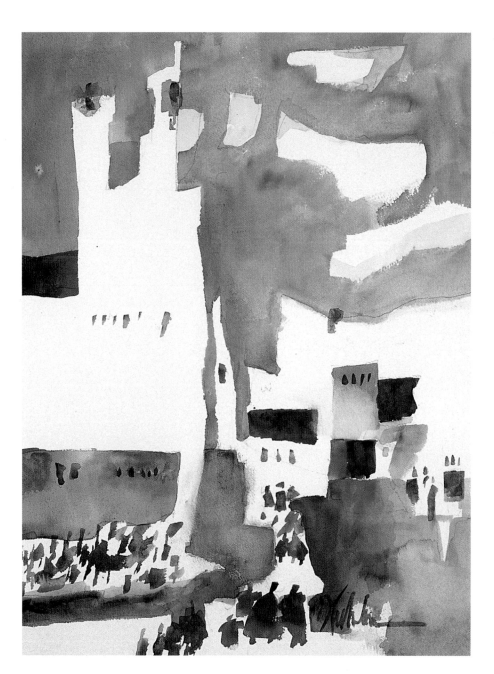

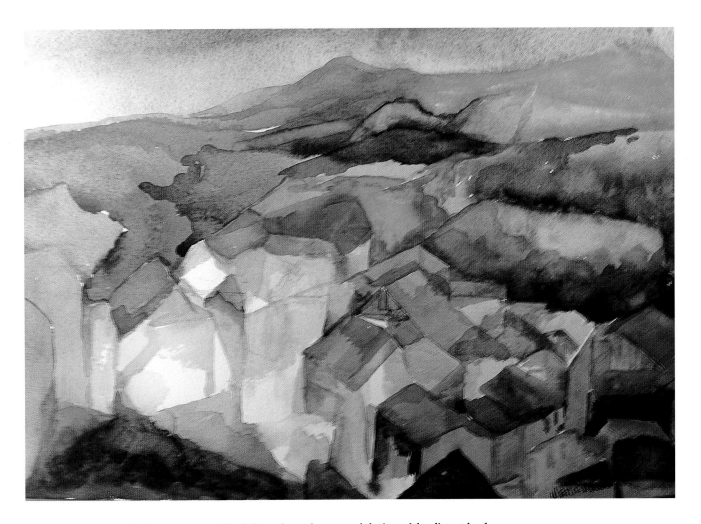

ALICE W. WEIDENBUSCH
French Mountains
10.75" x 14.5" (27 cm x 37 cm)
Winsor and Newton 140 lb.

The light, colors, shapes, and design of the distant landscapes remained fresh in my memory after a trip to the French countryside. Using photographs as reference, I created *French Mountains*. The design of the winding streets of the small town and the rooftops, long a fascination to me, suggest the foreground. The rhythm of color and shadows gives an abstract quality to the background.

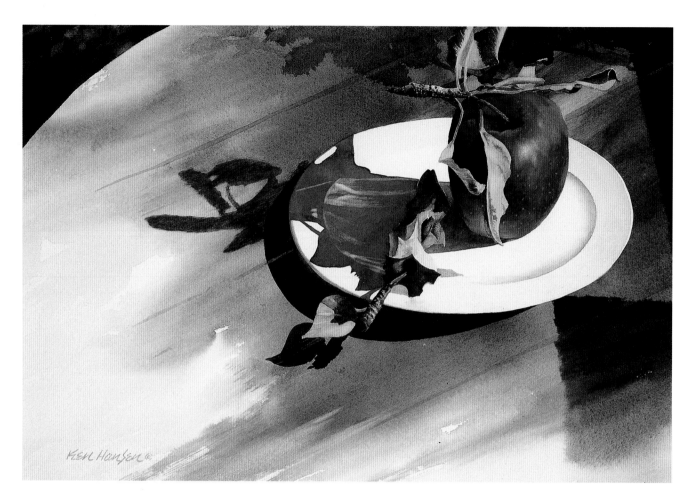

KEN HANSEN
An Apple a Day
13" x 19" (33 cm x 48 cm)
Arches 300 lb. cold press

My subject choice was spontaneous, having just eaten a wild apple and placing its core on the plate. Use of shadow in *An Apple a Day* not only gives dimension to the primary subject matter, but is essential to the overall composition. Shadows are cast from a great distance, a medium distance, and from close up. There is also a variation in the ability of the shadow to vary in color by the reflective quality of the surface it falls on. Shadow colors differ by virtue of the varying reflective intensities—the blue sky of the sunny day is reflected in the shadow of the apple on the highly reflective plate, but the table itself has no reflective quality.

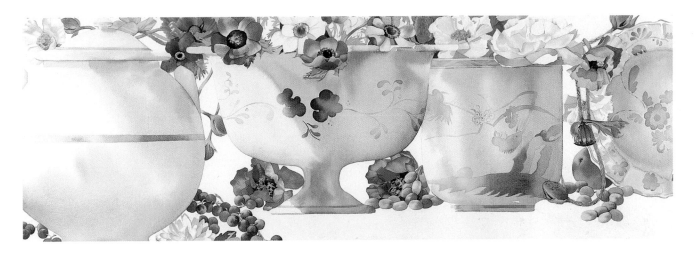

DEBORAH ELLIS
*Anemones, Poppies, Peonies,
and Grapes*
14" x 41" (36 cm x 104 cm)
Arches 555 lb. cold press

My work always features the many qualities of light—its creation of shadows and the light within, and its evocation of temperature, weather, and mood. I choose objects for how they absorb or reflect light, always using transparent watercolors. I am fascinated by the potential in layering additions of wet wash into one another. The suspension of different pigments, while still revealing the white of the paper, is the essence of what watercolor can do.

CINDY POSEY SINGLETARY
Sunflower II
22" x 30" (56 cm x 76 cm)
Arches 140 lb. cold press

I enjoy painting flowers because of their shapes and the challenge in achieving their intense colors. A strong light pattern interests me, and I try to capture the feeling of sunlight hitting different areas of the leaves and petals. In *Sunflower II*, the light helps communicate the essence of the sunflower's beauty and the warmth of a summer day. I used a combination of wet-in-wet and drybrush techniques with transparent watercolor. The 140 lb. cold-press paper allowed me time to make changes while working.

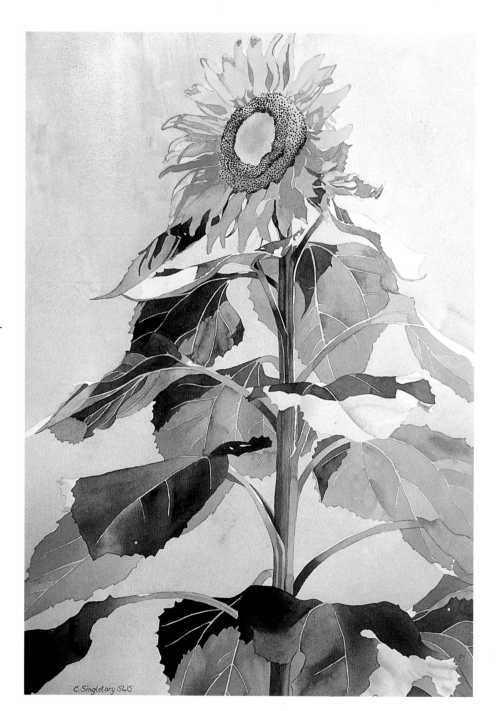

LIBBY TOLLEY
Autumn Twilight with Purple Mountains
20" x 16" (51 cm x 41 cm)
Rising 100% cotton 4-ply
Watercolor with gouache

Light is the essence of my landscape painting, and the quality of light determines my palette, value range, focal point, and what I respond to emotionally. On location, I look for the way light falls and then determine how warm or cool it is, its relative color, and how it affects the coloration of the landscape. The warm light that inspired my painting changed a blackened, ash-covered mountain range to glowing violet and purple. Any other type of light would have made an entirely different painting. Since I was painting rich mid-tones and darks and wanted a soft, warm light, I used a soft-finish paper that would absorb the paint.

JOAN RADEMACHER
Burst of Spring
14" x 21" (36 cm x 53 cm)
Arches 140 lb. cold press

The use of light and its effect on composition and color value is the most important part of my work. In *Burst of Spring*, the cast shadows provide a good contrast to the sunny light and luminous forsythia. The darks of the foliage surrounding the flowers added to the impact and the wrought-iron fence gave it the final contrast.

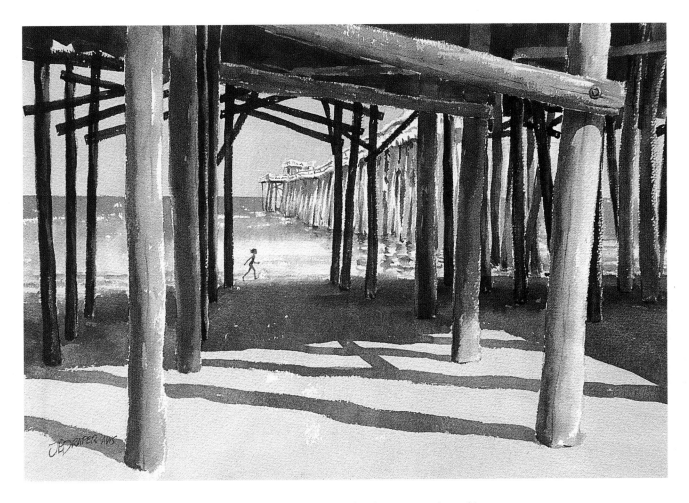

J. EVERETT DRAPER
The Pier
14" x 21" (36 cm x 53 cm)
Arches 140 lb. cold press

The Jacksonville Beach pier has been an ongoing subject of mine. The compositional design possibilities of the pier as both a structure and a figure as well as the people fishing from the topside, yield countless painting opportunities. In *The Pier*, the strong verticals of the pilings plus the horizontals of the shadow pattern become a frame for a focal point.

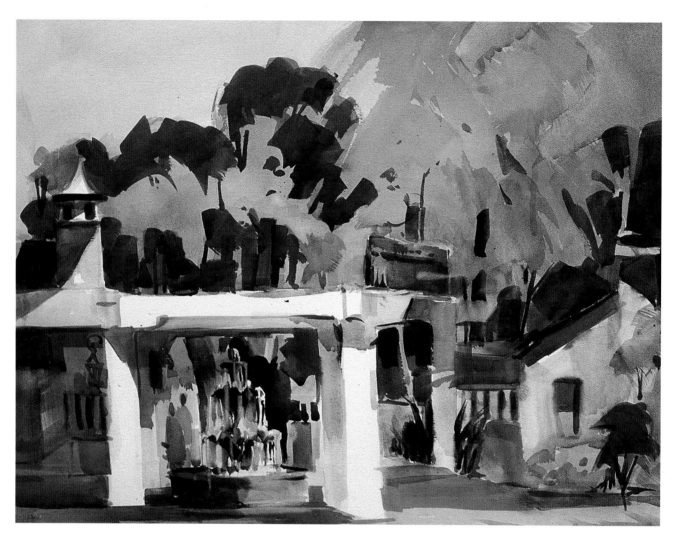

RICH BUCHWALD
Don't Drink the Water
22" x 30" (56 cm x 76 cm)
Arches 140 lb. cold press

I chose this subject because the pattern of light and dark in the shadows added emphasis to certain portions of the scene while subordinating others. Working on location, I brushed an outline of the composition and then immediately washed in the darks, establishing the light on the vertical posts and buildings, as well as the dot-and-dash texture of the fountain. Light and shadow can define and emphasize the most important elements of a picture, and their pattern is more important than their intensity.

JENNIFER D. BOGET
Light Play
13.75" x 21.5" (35 cm x 55 cm)
Arches 300 lb. cold press

The sun streaming in the window on a cold, wintry morning made the wood glow with warmth and the objects on the kitchen table cast fascinating shadows. The laciness of the basket's shadow, the solidity of the pot and plant, and the reflected color of the leaves on the table became my painting's subject. The challenges in *Light Play* lay in conveying changes in light and texture and painting the shadows not as a layer of darker paint, but as alive, glowing patterns.

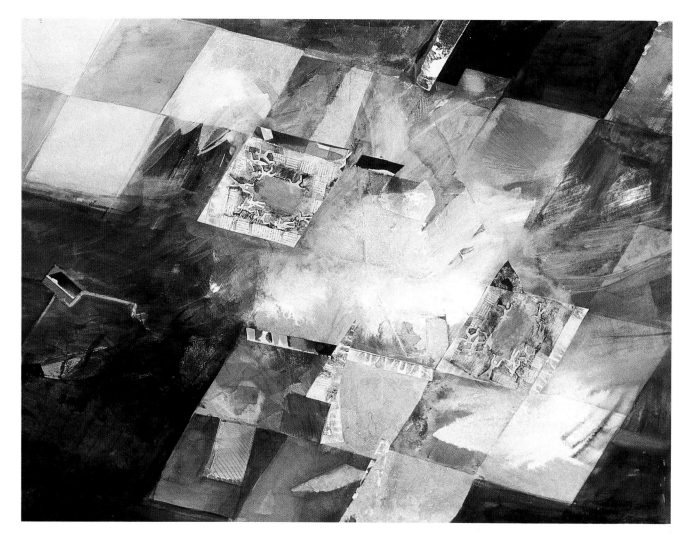

ELIZABETH CONCANNON
From a Distance
22" x 30" (56 cm x 76 cm)
Lanaquarelle 140 lb. cold press
Watercolor with gouache and collage

From a Distance is an effort to abstractly describe an area of the city from above. I structured it on a grid to look orderly, as cities usually do, and wanted to include the fast pace of the city. After the initial background washes had dried, I surrounded the action areas of the city with the darkest darks, creating shadowy regions enlivened with spots of color. The brighter color, more colorful lights, and centers of activity include hand-painted bits of color on paper or sections of other watercolor sketches collaged to define edges and shapes.

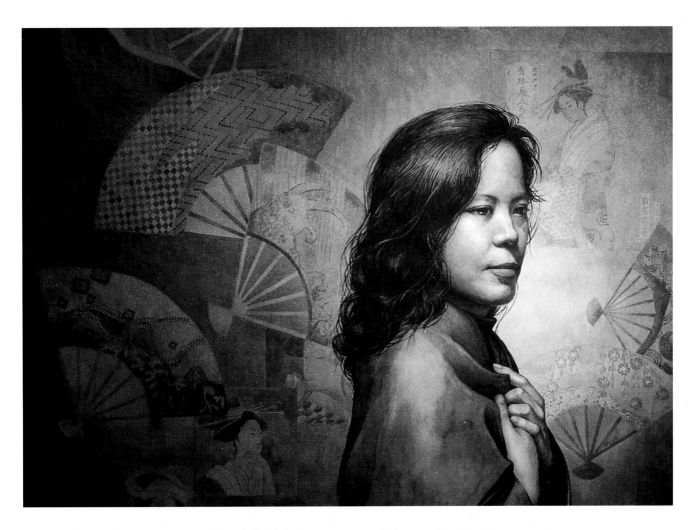

YUMIKO ICHIKAWA
Self-Portrait
22" x 30" (56 cm x 76 cm)
Strathmore 80 lb. cold press

I used dim light to express a meditative mood in this self-portrait. The light is painted so it looks like inner light radiating from my soul rather than natural light stemming from an outside source. By using transparent watercolor and layering colors, I was able to accomplish the soft, delicate colors and details that enhance the painting's contemplative atmosphere.

BARBARA MILLICAN
Compote
22" x 30" (56 cm x 76 cm)
Arches 140 lb. cold press
Watercolor with acrylic

Compote reflects the influence of
the Cubist painter, Georges Braque.
The abstract design creates the
illusion of simultaneous viewpoints
using rich tones and subtle neutrals
interposed with bright lights.
Although my use of lights is arbi-
trary and not from an actual source,
it creates a vibrancy when used with
the deep, rich colors. Acrylic is the
most useful medium to achieve this
effect because the white paint itself
has a richness to it that cannot be
found in the white of the watercolor
paper. Using acrylic in both opaque
and transparent passages heightens
the effect of the darks and lights
and the textures and patterns in the
composition.

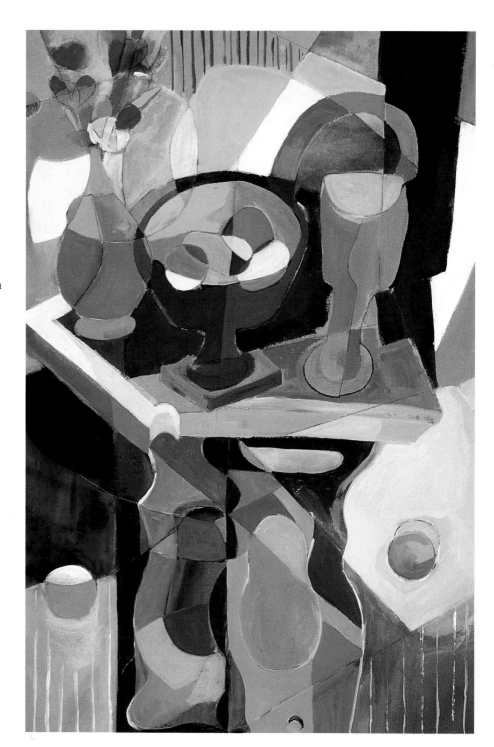

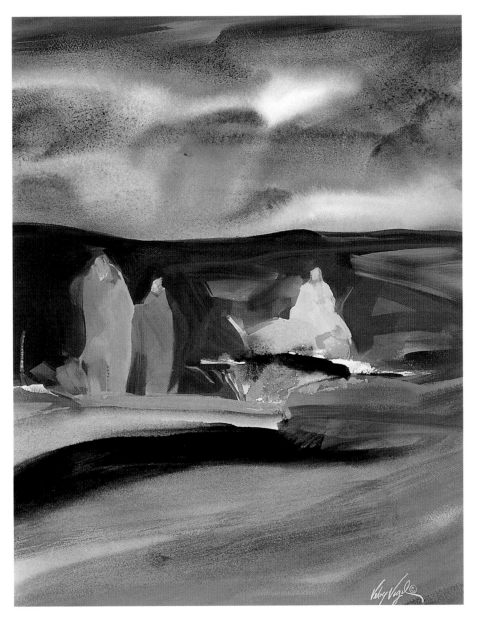

VELOY J. VIGIL
Timeless Story
21.25" x 17" (54 cm x 43 cm)
AHC 3-ply
Watercolor with acrylic and gouache

The source of my imagery is Taos, New Mexico, where the color and light have interested artists for almost 100 years. Using contrast to intensify the feeling of light, a strong horizon line defines space in *Timeless Story*, creating a dark landscape into which the focal-point figures can be placed. A light and dark stormy sky creates a heavy atmospheric presence.

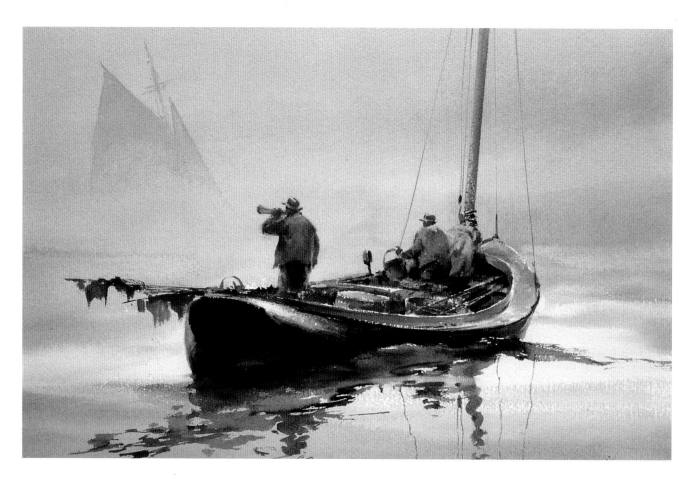

MARSHALL W. JOYCE
The Warning
14" x 21" (36 cm x 53 cm)
Arches 300 lb. cold press

The planning and research for *The Warning* took more time than the actual painting. To maintain spontaneity and avoid a worked-over look, I painted it in one sitting. The reflections in the water helped to add interest to the subject. With the thick blanket of fog and the calm sea, I tried to convey the precarious and lonely life of the simple seafarer who has nothing but an old foghorn to protect him from the lurking dangers.

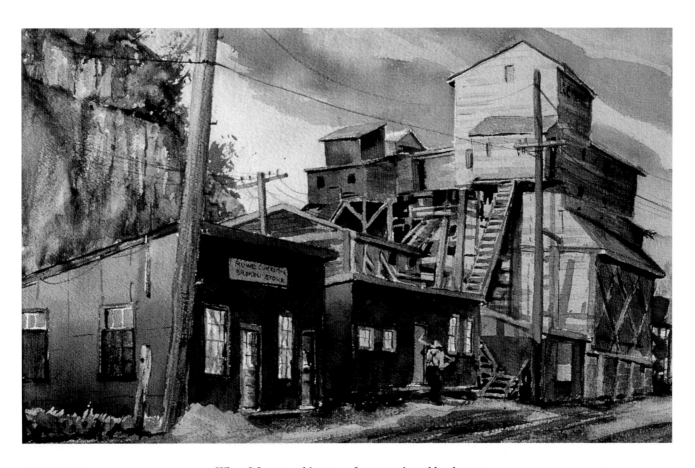

JACK JONES
Stone Quarry
13" x 21" (33 cm x 53 cm)
Arches 300 lb. rough

When I first saw this scene, I was captivated by the way light and shadow provided contrast and form and contributed to the strong design. Working on location, the background rocks and trees and the road gave me an opportunity to introduce texture to the painting. I did this by using a rough-textured paper and drybrushing for a lacy effect.

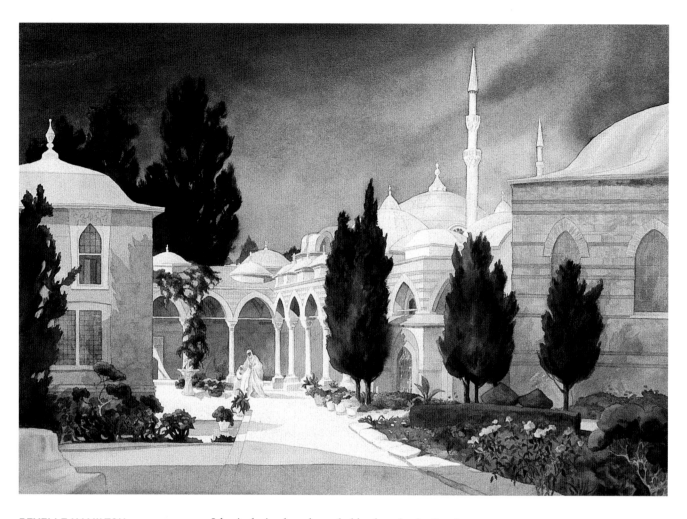

REVELLE HAMILTON
Turkish Courtyard at Night
20.5" x 29" (52 cm x 74 cm)
Winsor and Newton 260 lb. cold press

Islamic design has always held a deep fascination for me. Starting with photographs I took twenty-five years ago, I tried to convey the sense of mystery, exoticism, and elegance of remembered images. A night scene, with the play of moonlight and shadow, seemed to express the otherworldly, dreamlike quality that I recalled. I interpreted the counter-changes of dark against light by using a limited palette of colors, all mixed with Payne's gray. For the lamplight, I chose Indian yellow and lamp black for a more transparent warmth.

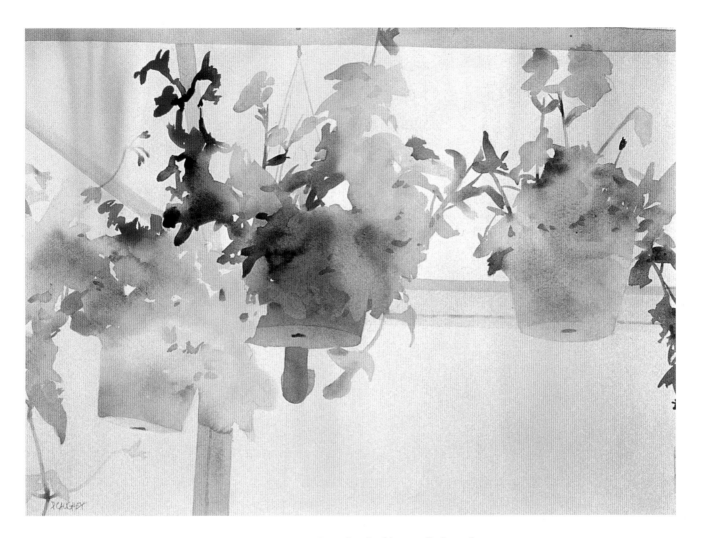

PAMELA CAUGHEY
Hanging Baskets
22" x 30" (56 cm x 76 cm)
Arches 140 lb. cold press

In *Hanging Baskets*, I was inspired by a walk through a favorite greenhouse to capture the feeling of the bright, diffused light that made the subject matter softer and flatter than ordinary direct light. Painting wet-in-wet in the background using Winsor yellow, Winsor green, and Winsor red set up a glowing, light-filled surface on which to paint the flower baskets. Using mostly non-staining, transparent pigments, as well as a few sedimentary ones, the baskets were painted high key to convey the airiness and diffuse light of the greenhouse.

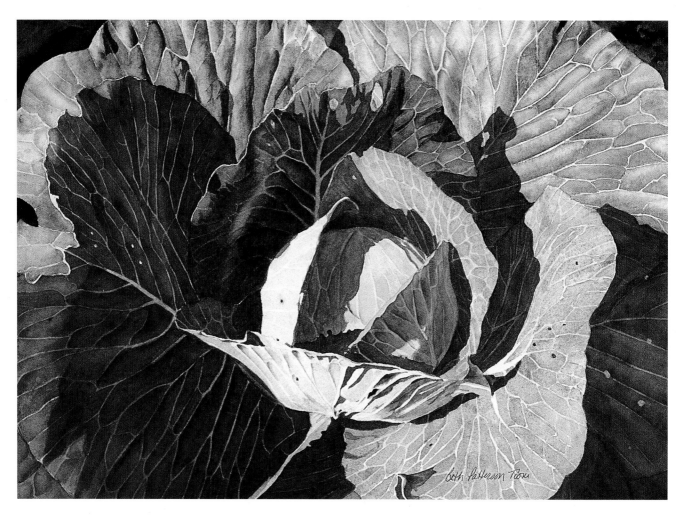

BETH PATTERSON TOONI
Cabbage Greens
14" x 21" (36 cm x 53 cm)
Arches 300 lb. cold press

When choosing subjects for my paintings, I look for strong design and composition, as well as rich color and texture. The late afternoon sun in *Cabbage Greens* provided just that. To capture the feeling of the sun's warmth, I exaggerated the values of the light-struck areas and gave the painting a strong, warm color scheme. I used thin washes of transparent color in the leaves in full sun and contrasted them with the heavier, darker surfaces in shadow. To avoid monotony, I pushed beyond the local color of the cabbage and used a variety of warm and cool yellows, blues, and reds.

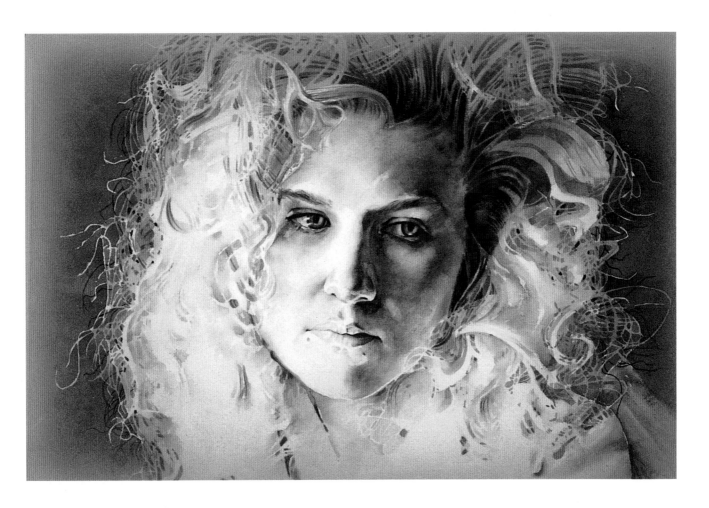

JERRY H. BROWN
Angela
22" x 28" (56 cm x 71 cm)
Arches 300 lb. cold press

The success of *Angela* was dependent more on a dramatic light source than on color. Cool grays established the desired mood of the painting and traditional watercolor techniques of wet-in-wet and wet on dry were used for the portrait. To complete the work, an airbrush was used to create the smooth background.

JERRY H. BROWN
Quilt and Rocker
24" x 17" (61 cm x 43 cm)
Arches 300 lb. cold press

The use of dramatic lighting and a cool underpainting in shadowed areas aids in the definition of form. Warm and cool colors were used in the shadows and highlights to add dominance, and accents were added with warm transparent washes applied over the cool colors. I make use of soft and hard edges in contours as well as in wrinkles and shadows. An attempt is made to incorporate spontaneous areas of watercolor into a work that is otherwise more controlled.

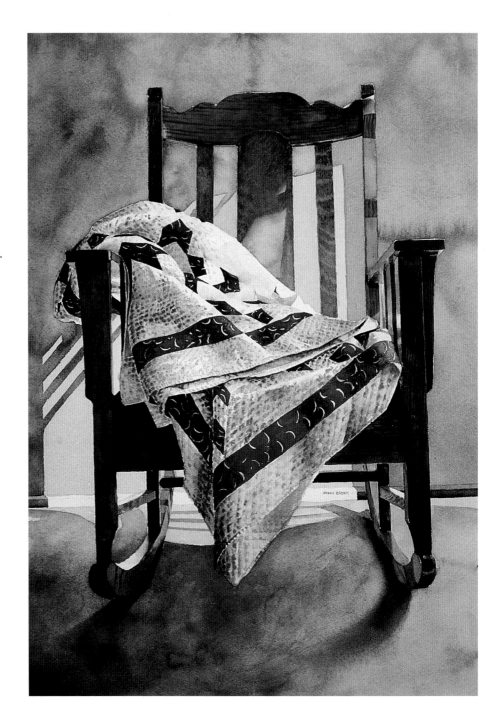

BARBARA SCULLIN
Nature's Tapestry
20" x 30" (51 cm x 76 cm)
Arches 300 lb. cold press

With nature as an inspiration, my work is abstract, combining hard-edge with soft-edge. Light is an integral part of my paintings as it generates excitement, defines forms, heightens the mood to be expressed, and invites the viewer to move from one area to another. After several initial color glazes, I paint wet-in-wet to soften areas, allowing light to come through. This is balanced against the rich, hard-edged darks. Nature provides the inspiration for my paintings.

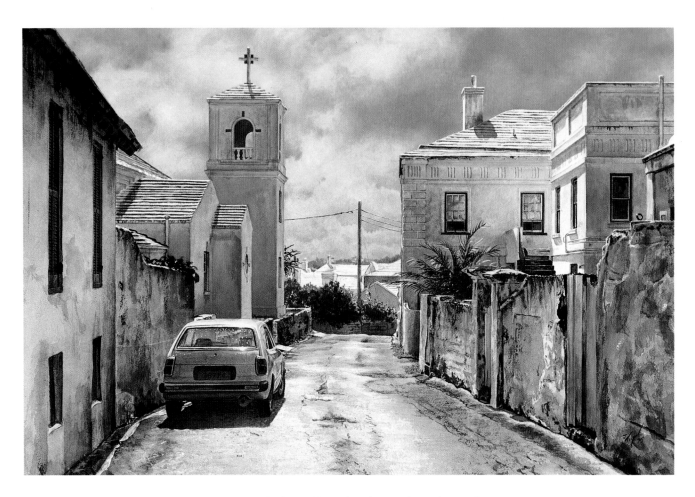

JAMES TOOGOOD
St. George's–Bermuda
14.5" x 20.5" (37 cm x 52 cm)
Arches 140 lb. cold press

Painting shadows effectively relies on the understanding of the interconnection of light, its intensity, and the shadows that result. *St. George's—Bermuda* contrasts the time-worn stone buildings of this historic town with the glass and metal of a contemporary automobile, bathed in sunlight after a brief rain shower. Bermuda's brilliant light seems to reflect in every direction, producing vibrant color within the shadows. To create shadows that have depth and luminosity, I apply thin washes of many different colors.

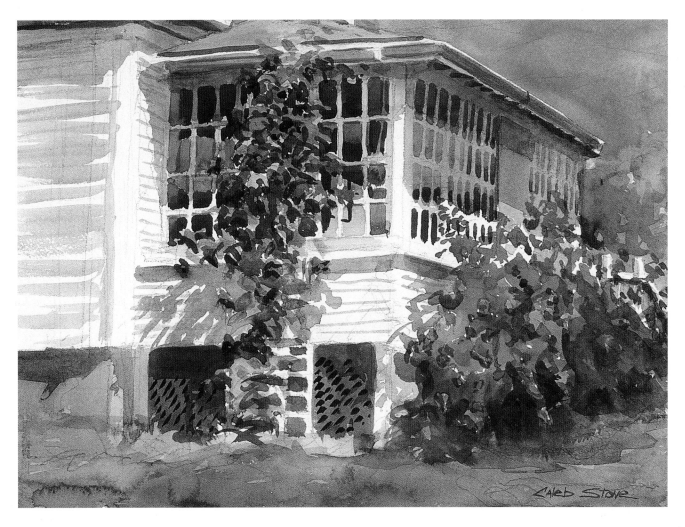

CALEB STONE
Climbing Clematis
11" x 15" (28 cm x 38 cm)
Arches 140 lb. cold press

Working on location allows an accurate, honest portrayal of my subject matter. I find photographs deaden color and values. In *Climbing Clematis*, I tried to capture light throughout the painting, using the white of the paper for the most direct sunlight. Dappled light coming through the clematis creates cool shadows with warm, reflected light within. I use simple value patterns in my work—light, mid-light, mid-dark, and dark. In planning, I try to use mostly darks with a few lights, or in this case, more lights than darks, so the finished painting is not too balanced.

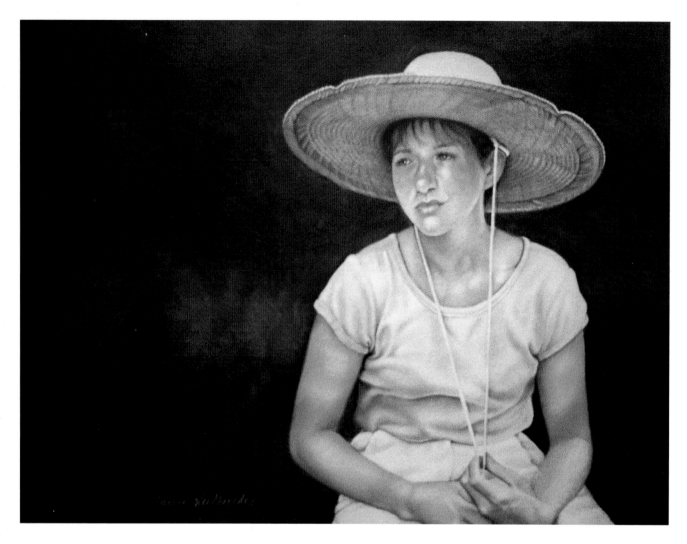

SHARON N. WEILBAECHER
Straw Hat
20" x 26" (51 cm x 66 cm)
Arches 300 lb. cold press
Watercolor with gouache

In *Straw Hat*, I wanted to capture the warmth of the sun on my daughter and the contrast of the crisp, flat brim of the hat with the soft contours of her young face. Light established the time of day, the temperature, and the mood. Using strong highlights and high-key painting contrasted with strong darks were essential to depict Susan's moment in the sun. Leaving the white of the paper for the brightest areas, I layered washes of transparent watercolor for the figure and hat, and added details with drybrush. Gouache was used to clean up ragged edges on the hat brim.

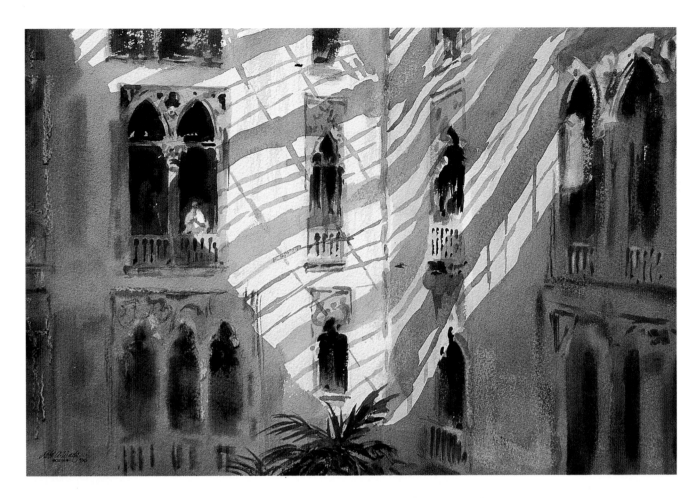

ROBERT A. WADE
The Atrium, Study #1
14" x 20" (36 cm x 51 cm)
Waterford 640 gm rough

While visiting the Isabella Stewart Gardner Museum in Boston, I was confronted by the wonderful shadow patterns created by the grand skylight. The strong abstract line patterns instantly inform the viewer of the structural pieces that cast them. All shadows indicate the character of the shape casting them, which allows the use of objects beyond the picture plane and lets the viewers use their imagination.

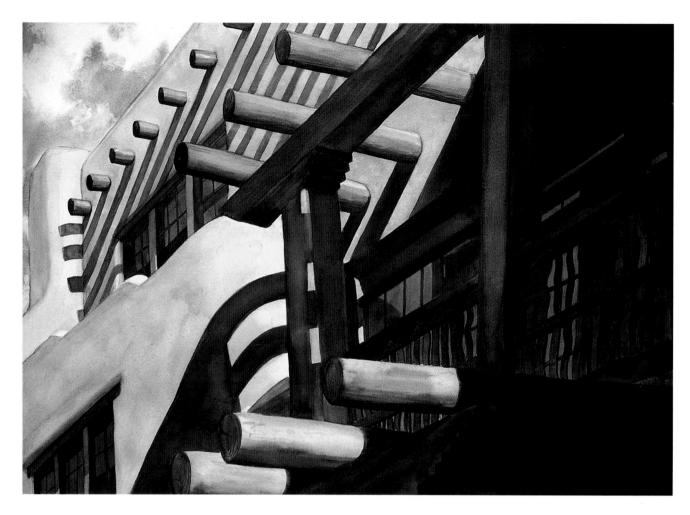

JUDITH HURST BAER
Southwestern Shadows I
22" x 30" (56 cm x 76 cm)
Lanaquarelle 140 lb. cold press

The Inn of the Anasazi in Santa Fe, New Mexico was the inspiration for *Southwestern Shadows I*. The linear patterns, value contrast, and repeated shapes were the basis of this design. I limited my palette to a complementary scheme to create the greatest contrast of the light and shadows. Painting with warm and cool complements (burnt sienna and manganese blue) helped to create the illusion of depth. With each glaze I added more and more color and intensity, with the resulting color mixtures and the granulation of the manganese blue providing the mood for the composition.

DIANA M. ARMFIELD
Central Park, New York
8.25" x 5" (21 cm x 13 cm)
Sanderson 140 lb.
Watercolor with pencil

Central Park, New York was developed from drawings I made during a walk in Central Park. Shadows divide the rectangle into unequal areas, each containing an area of particular interest made by darker accents of shadows and color. The shadow against the curb leads into the darker shapes above, setting up an important tilt and an embracing curve. The shadow shapes link to give a flow for the eye to follow. My technique of translucent touches comes from simply painting what I observe, hoping it will express the luminosity and freshness of the scene.

JOAN H. McKINNEY
The Waiting Room
22" x 29" (56 cm x 74 cm)
Arches 140 lb. hot press

The shapes created by shadows, especially on white buildings, are most important to the composition of my painting. I particularly like old buildings and travel on sunny days in search of churches and town centers that contain historic areas. Photographing these from many angles provides me with numerous choices for the kind of painting I want to create. I prefer hot-press paper to obtain the cleaner, sharper lines necessary in architectural paintings.

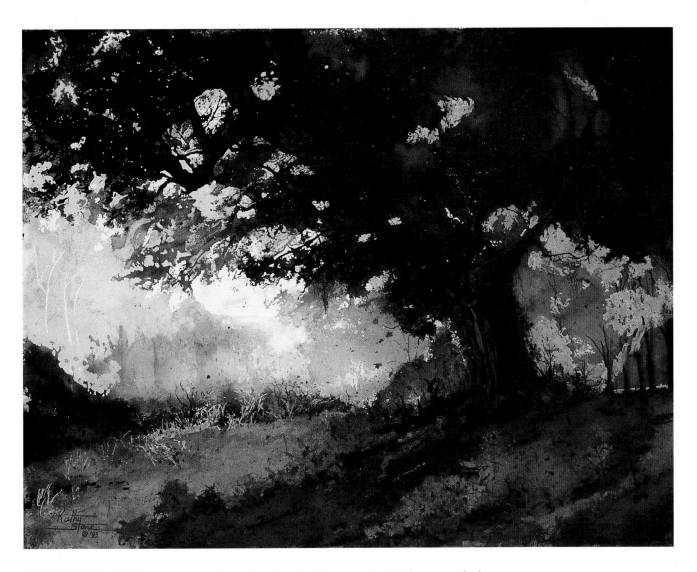

KATHY MILLER STONE
Grand Old Oak
22" x 30" (56 cm x 76 cm)
Arches 300 lb. rough

One of my favorite old sayings is: "Life has many shadows, but 'tis the sunshine that makes them." That summarizes the thought I had while standing in the shadow of a grand old oak tree in a family cemetery. I made a pencil drawing of the scene on watercolor paper and masked out the sun-struck areas so I could pour mixtures of warm and cool darks over the entire paper, using Ernie Young's Tilt Table to regulate the flow. When the paper was completely dry, I removed the masking agent and painted into the light areas to define limbs, foliage, and foreground shapes.

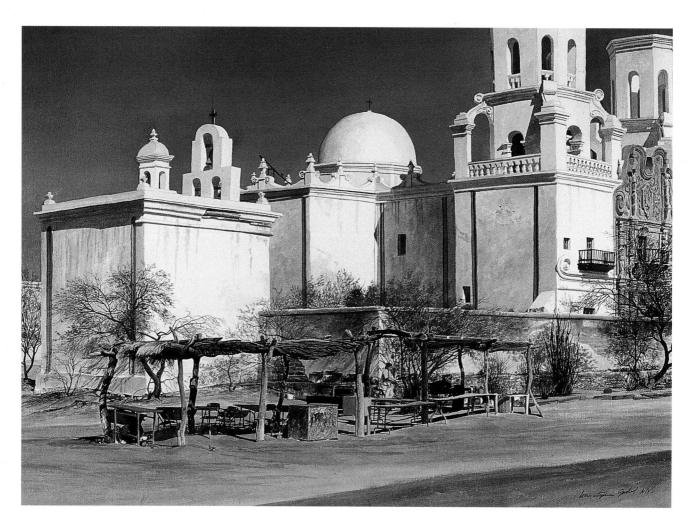

LOUIS STEPHEN GADAL
San Xavier Del Bac
28" x 40" (71 cm x 102 cm)
Arches 555 lb. cold press

The San Xavier Mission outside of Tucson, with its white stucco walls contrasted against the strong blue sky of southern Arizona, gave me the opportunity to work with direct and reflected light. To achieve the desired result with transparent watercolor, I layered a series of washes one over the other, with some areas of this painting having as many as six layers of color.

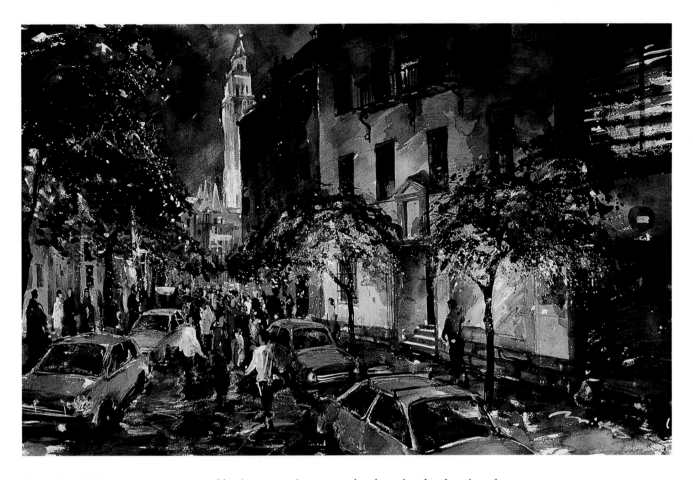

MICHAEL LENN
It Could Be Anywhere
24" x 36" (61 cm x 91 cm)
Arches 140 lb. cold press
Watercolor with oil pastel and tempera

I begin my creative process by observing the changing of light and shadows and focusing on the mood. In *It Could Be Anywhere*, the twilight elicits a mystical state and sense of anticipation. With an unnatural source of light, the shadow is above. I used watercolors to create a transparent, elusive effect. Oil pastel is primarily used to resist watercolor, but also to create an unexpected misty impact. There is an absence of subject and several light centers diffuse the focus. Shadows are inseparably intricate and critically essential to this work.

PAT TRUZZI
Echoes
30" x 22" (76 cm x 56 cm)
Winsor and Newton 260 lb. cold press

Looking through old family albums, I was challenged to capture the feeling of people frozen in time becoming blurred by the intervening years. The figures stand bathed in the warm winter light with unseen trees creating a dappled pattern of shadows. Cool, diffused light, and a stylized pattern of trees frame the scene. The shifts of light from warm to cool were essential to the feeling of another time and place. The soft, absorbent 260 lb. cold-press paper allowed me to work wet-in-wet, creating muted tones by adding complements and letting the paint mix and flow to create the soft, slightly out-of-focus quality I sought.

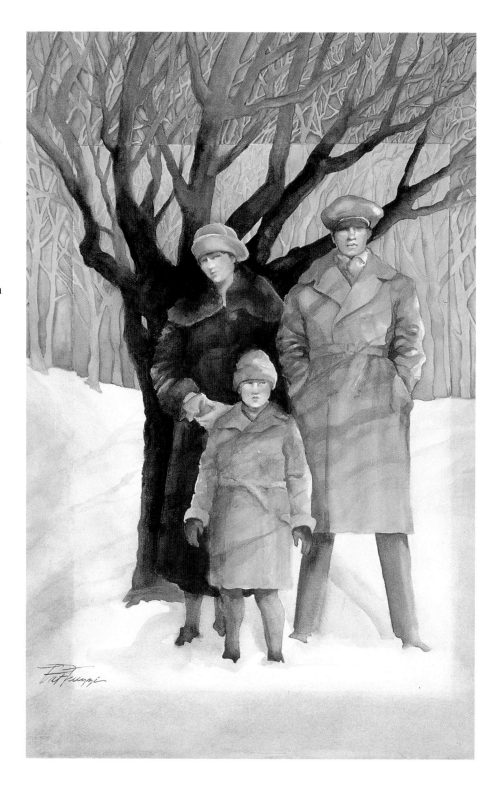

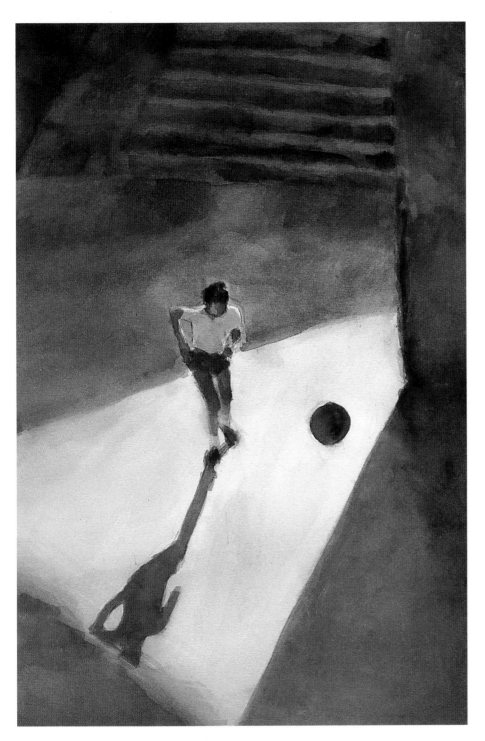

SUSAN C. SCHULTZ
Remembering Dubrovnik
19" x 10.5" (48 cm x 27 cm)
140 lb. hot press
Watercolor with gouache

In 1989, while walking around
the old walled city of Dubrovnik,
Yugoslavia, I looked down and saw a
young boy playing soccer. The light
was so dramatic and he seemed so
carefree. Later, when I heard about
the bombing of Dubrovnik, my
heart sank, remembering what a
beautiful, old city it was. When I
pulled out my photographs and
painted this piece, I was hoping to
capture a moment that, perhaps,
no longer exists.

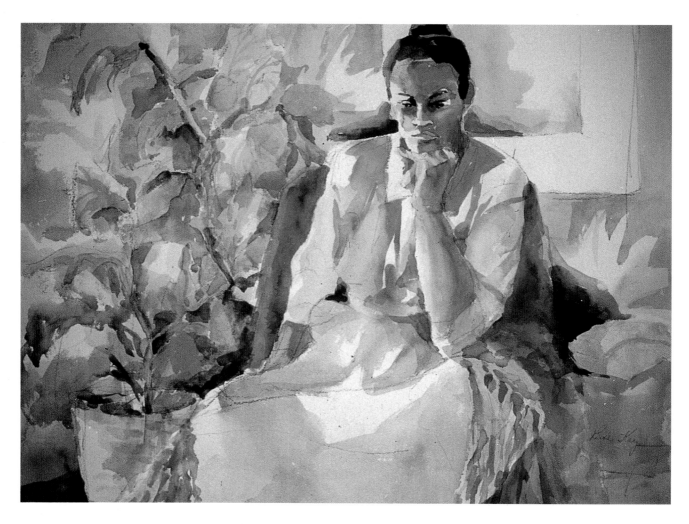

RUTH KARP
Meditation
22" x 30" (56 cm x 76 cm)
Arches 140 lb. cold press

If given a choice of only one subject matter to paint, I would choose the figure. To capture the mood and feeling of a pose and the way shadows fall on the face and form is an exciting challenge to me. An object is not visible unless there is light, so when I paint, I look for lights and darks. The beauty of transparent watercolor is in the loose application of paint, the saving of whites, and the way it moves in unique ways. In order to be fresh and clean, a sure and simple stroke is essential.

JERRY ROSE
The Secret
20" x 26" (51 cm x 66 cm)
Illustration board
Watercolor and egg tempera

I have found that contrasting values, when placed next to one another, strengthen each other. In *The Secret*, the background was darkened considerably in order for the primary figure of the little girl to appear bathed in light. This extreme contrast helped reinforce the illusion of form and light. Egg tempera enabled me to carefully control the modulation of the values.

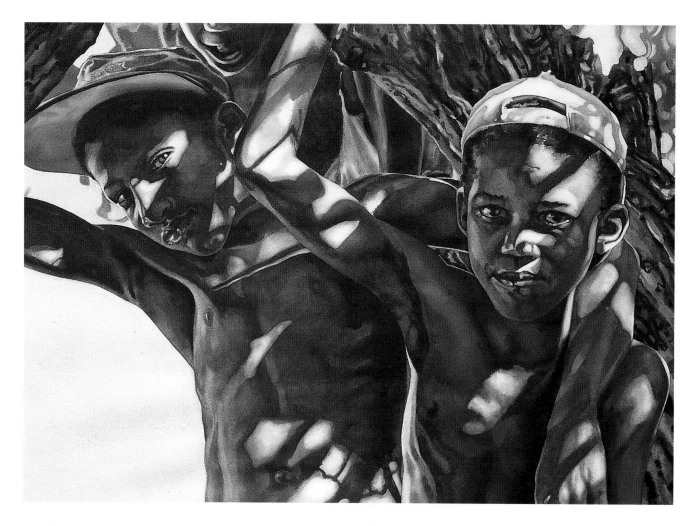

KAREN FREY
Three Boys—Climbing Trees
25" x 38" (64 cm x 97 cm)
Lanaquarelle 140 lb. cold press

Shadow was the inspiration for this painting; I used it to develop my compositional balance between value, shapes, and color. Although the content is figurative, the concept is about light. Shadow patterns subtly reveal the form of the boys' bodies and more strongly suggest a light source of sun filtered through the foliage. I primarily work wet-in-wet with transparent watercolors.

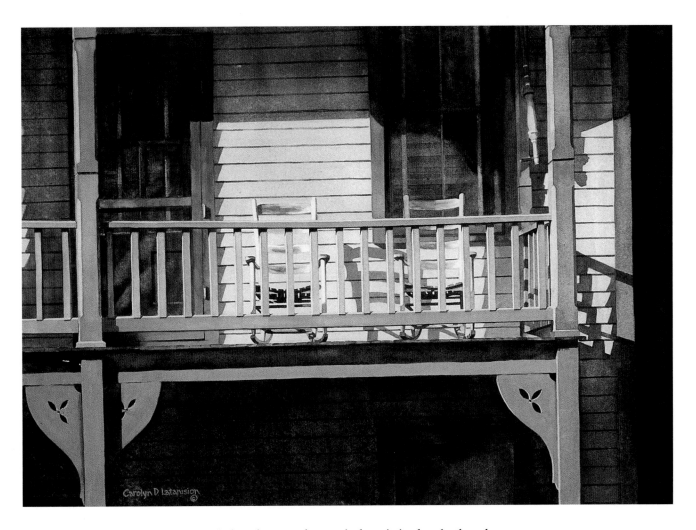

CAROLYN D. LATANISION
End of Summer—Mohonk
22" x 30" (56 cm x 76 cm)
Twinrocker 400 gm cold press
Watercolor with casein

I often choose to do a particular painting less for the subject than for the abstract composition of light and shadow. In this case, I liked the variety of patterns of light and dark. To achieve the depth in the dark areas, especially since there wasn't an overall depth to the subject, I used watercolor for its translucence. For the strong, sharp clearness of the brightest light objects, I turned to casein, a very opaque medium. In this manner the contrast between light and dark is further heightened.

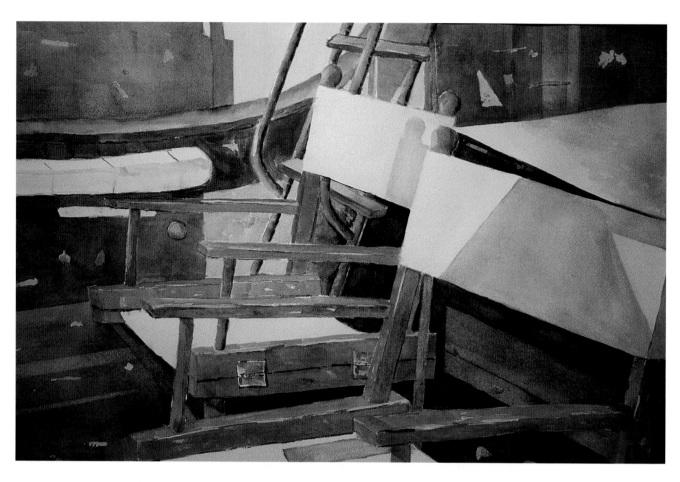

SANDY KINNAMON
Relaxing
20" x 27" (51 cm x 69 cm)
Arches 140 lb.

In *Relaxing*, I simplified the values and the shapes with the white shapes bathed in light, creating abstract designs. Quality of light can direct the mood and change an ordinary subject into an exciting composition of light and shadows. Shadows help produce depth in otherwise limited space. The size, shape, and placement of the white areas help tie the painting together. Painting the background with soft-edged dark values contrasts with the hard-edged white cloth of the chairs. Mid-tone values of the wood on the chairs add warmth and structure.

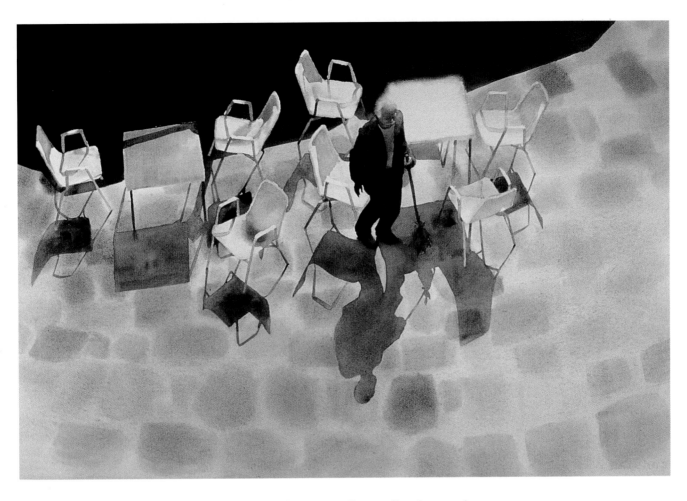

JEANNE DOBIE
Piazza Patterns
20" x 30" (51 cm x 76 cm)
Arches 140 lb. cold press

While watercolor is an excellent medium for capturing light in a scene, I take it a step further and focus on developing the light shapes into a powerful pattern. I analyze, adjust, and rearrange light shapes endlessly in my composition to create the most arresting pattern I can before I paint. As a result, in addition to capturing the nuances of light, I have provided a distinctive design for the viewer to enjoy.

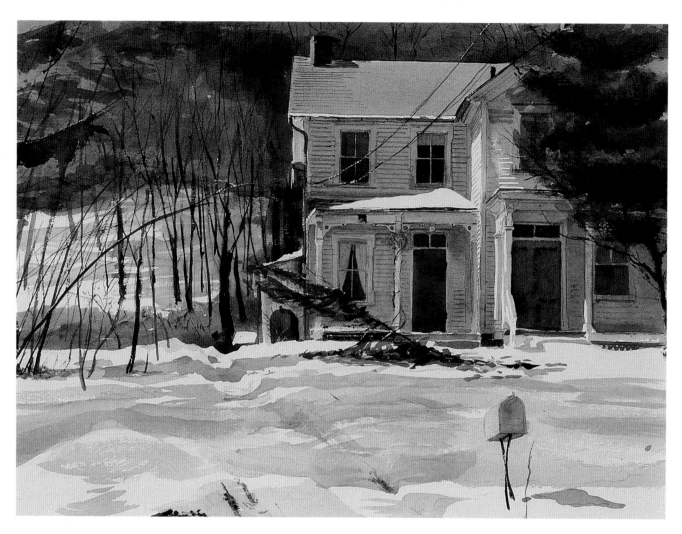

JOHN C. BERMINGHAM
Rough Winters
20" x 26" (51 cm x 66 cm)
Saunders Waterford 300 lb. cold press

When looking for subject matter, old weathered buildings attract my attention. With shadow, I try to define interesting white shapes and also enhance the mood and drama of the painting. The long horizontal shadows in the foreground define the undulations in the snow and impart a quietness to the scene.

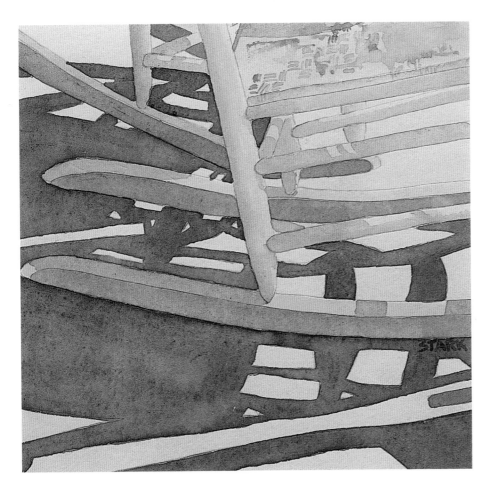

NANCY M. STARK
Two Yellow Rockers
12.5" x 13.75" (32 cm x 35 cm)
Arches 300 lb. cold press

This painting of cast shadows was inspired by bright sun shining on a group of rocking chairs at the beach. The chairs are severely cropped because the center of interest is the complex shadow pattern. The shadows' shape allows the viewer to fill in the missing parts of the chairs. Using transparent watercolors, I painted the rocking chairs first and followed with a wash of Winsor blue and alizarin crimson to define the shadow. While still wet, alizarin crimson, Winsor blue, and Winsor green were brushed in and allowed to blend to create the subtle variations in the shadow color.

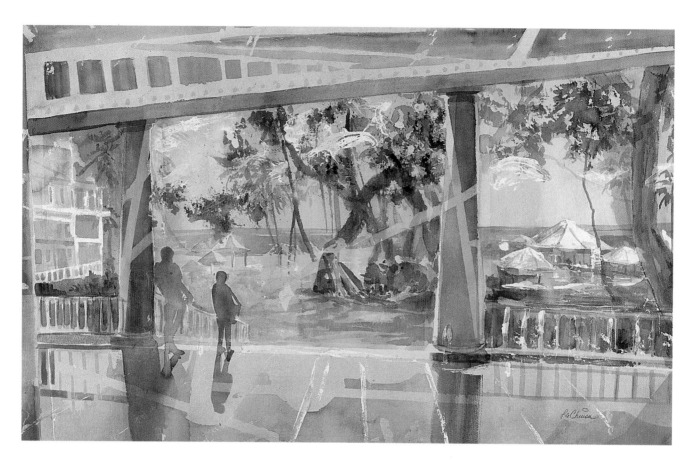

CAROL LA CHIUSA
Pacific Jewels
24" x 40" (61 cm x 102 cm)
Arches 140 lb. rough

In *Pacific Jewels*, I wanted to portray the effect of leaving the cool, dark interior of my Hawaiian hotel and being struck by the extreme light dancing on the water, off the pillars, and among the cabanas, like refracted light from a prism. The sky was painted vertically with pure colors of the prism. Both tape and mastic were used to separate reflected light into patterns and create jewels of pure color. Mixing was done on the paper for clarity. Shadows are shapes within shapes to sharpen the intensity of the light.

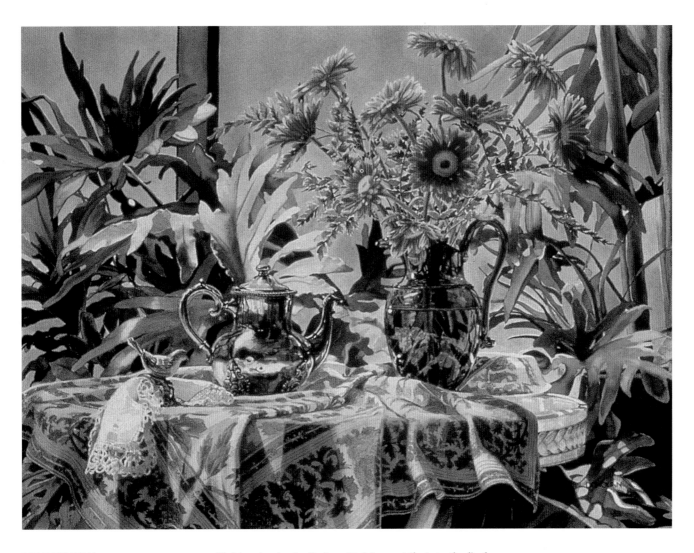

LIZ DONOVAN
Gerbera Daises
25.5" x 34.5" (65 cm x 88 cm)
Arches 300 lb. cold press

Light and color in *Gerbera Daisies* contribute to the lively, active mood as much as the gesture of plants, cloth, and other patterns. I set up my still lifes in direct sunlight and let the bright patches of light direct the viewer's eye through the composition. Where sunlight rests on colors, they are bleached near-white. As sunlight passes through transparent objects, such as leaves, flower petals, and colored glass, it brings out intense, jewel-like color saturation. Shadow areas of a sunlit arrangement are full of luminous color.

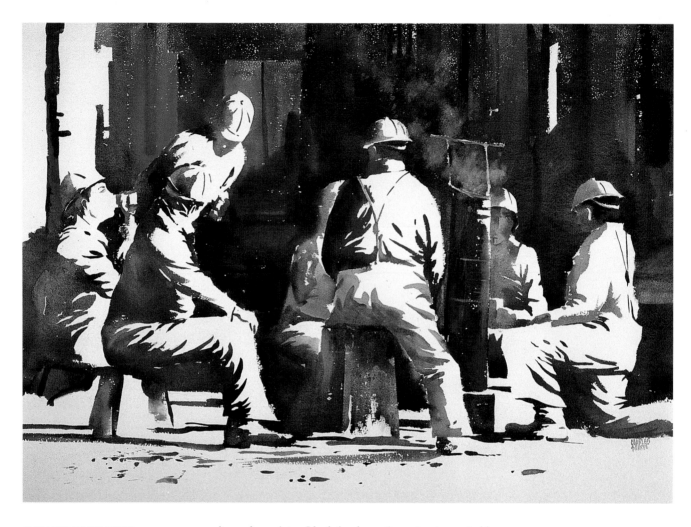

F. CHARLES SHARPE
Hard Hats
22" x 30" (56 cm x 76 cm)
Arches 140 lb. rough

As a value painter, I look for dramatic contrasts created by natural light as inspiration for my paintings. Any subject can provide inspiration if unique light is an element. I left the white surface of the watercolor paper untouched, allowing its roughness to create textures. As I painted the dark background with transparent watercolor, the figures began to emerge. The texture and light gave the figures form and gesture. The unbroken dark and light shapes lead the viewer's eye throughout the painting.

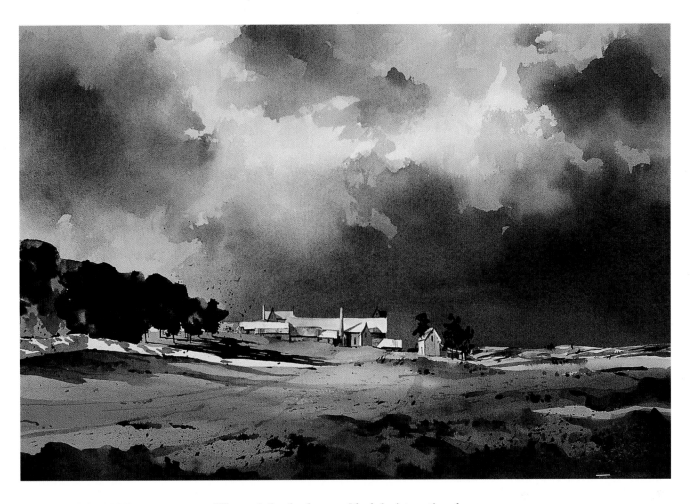

F. CHARLES SHARPE
After the Storm
15" x 22" (38 cm x 56 cm)
Arches 140 lb. rough

When painting landscapes, I look for interesting shapes with light and dark contrasts to create dramatic paintings. Using the white of the paper as light, I painted the vivid shadows with transparent watercolor. One application of paint created the shadow shapes while several glazes were used for the lighter shapes. The rough watercolor paper created texture. Shadows add depth to the sky and clouds, give form to the buildings and trees, and help describe the foreground. Shadows express the drama of a passing storm as the clouds move across the landscape.

LINDA BANKS ORD
Florence Series, #1
24" x 22" (61 cm x 56 cm)
Arches 140 lb. cold press

Investigating the effects of light on the figure and its environment is a primary concern of mine. Italy produces a strong natural light that was perfect for *Florence Series, #1*. I identified the pattern of light and color and modified it to produce a somewhat flattened contemporary picture plane, as opposed to traditional three-dimensional space that moves backward. Using transparent watercolors, I painted with my paper tacked vertically on the easel to amplify the spontaneous flow of color.

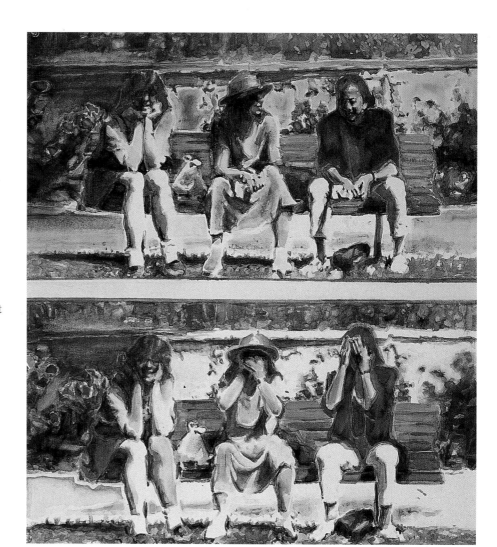

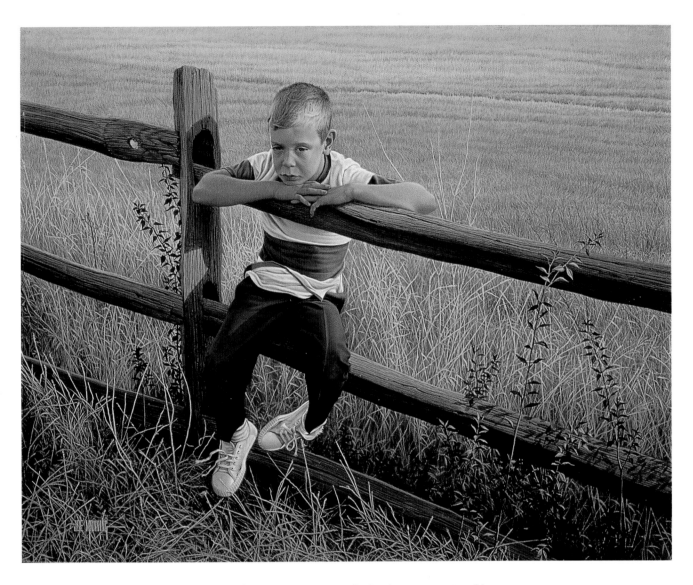

JOE MANNING
Michael
12" x 15" (31 cm x 38 cm)
Arches 300 lb. hot press
Watercolor and egg tempera

In order to capture nature, shadow is necessary to achieve form and solidity. I worked in watercolor first with round sable brushes and a chisel-edge brush to block in the painting on a hot-press paper, which I prefer when applying egg tempera over the watercolor. I worked wet-in-wet, and when completely dry, started numerous glazes of egg tempera with some drybrushing to achieve texture and values. I first captured light, half-tones, and shadow, then the textures, and lastly, the details.

JACQUELYN FLEMING
Postcards from the Edge #1
14.5" x 21.75" (37 cm x 55 cm)
Arches 140 lb. cold press
Watercolor with acrylic

I feel the shadows hold this piece together and are the strength of the work. I began painting over a discarded watercolor, allowing some of the color to show through. As I painted, I was anticipating what would happen, as I had no plan or preconceived subject matter in mind. Near the finish, I evaluated the work. Working in acrylics lets me make whatever changes are needed. This painting, with its elusive subject matter, suggests sunlight and strong shadows, but lets the viewer find their own interpretation of what they see.

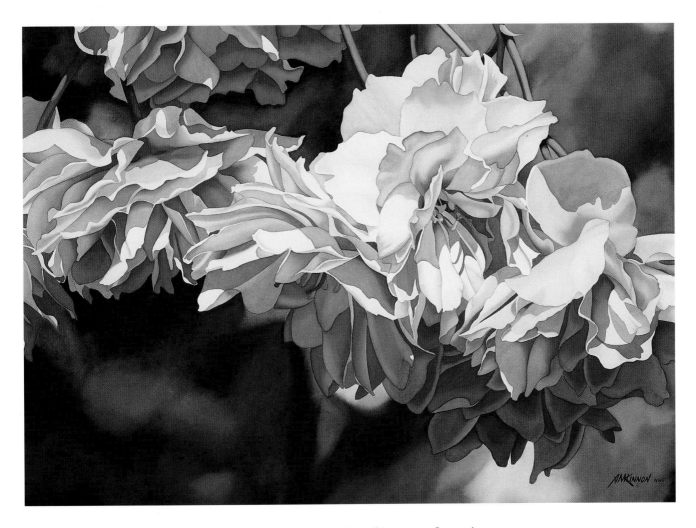

SUSAN McKINNON
Spring Blush
27.5" x 40" (70 cm x 102 cm)
Arches 555 lb. cold press

Studying the movement of sunshine across flowers in my garden through the day, I have captured some spectacular subjects for my paintings. Sunlight transforms the ordinary into the extraordinary and gives viewers a path through my painting. The cherry blossoms of *Spring Blush* were painted much larger than life, giving an intimate viewpoint. The sunlit effect was created by painting the cast shadows and using the white of the paper for dramatic highlights. I subtly worked light passages behind the shaded areas and kept the background dark around the highlighted blossoms.

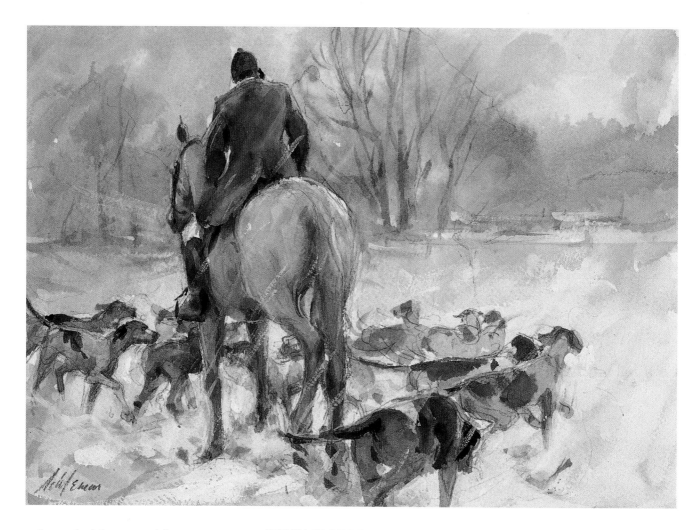

about the authors

BETTY LOU SCHLEMM
First Snow
11" x 15" (30 cm x 38 cm)
Arches 140 lb.

BETTY LOU SCHLEMM, *JUDGE*
Betty Lou Schlemm, A.W.S., D.F., has been painting for more than thirty years. Elected to the American Watercolor Society in 1964, and later elected to the Dolphin Fellowship, she has served as both regional vice president and director of the American Watercolor Society. Schlemm is also a teacher and an author. Her painting workshops in Rockport, Massachusetts are renowned. Her book *Painting with Light*, published by Watson-Guptill in 1978, has remained a classic. She also has recently published *Watercolor Secrets for Painting Light*, distributed by North Light Books, Cincinnati.

SARA M. DOHERTY, *EDITOR*
Sara M. Doherty graduated from Knox College in Galesburg, Illinois and took graduate-level courses in education at Loyola University in Chicago. She has been a teacher and a learning center director, and she has helped organize a number of national art competitions, juried exhibitions, and painting workshops. She also worked on the production and sale of an art instruction video with the noted watercolorist, Sondra Freckelton. In 1994, Doherty accompanied a group of artists and art lovers to Italy and reported on the workshop in an article published in *American Artists* magazine.

directory of artists

Diana M. Armfield, R.A., R.W.S. 117
10 High Park Road
Kew, Richmond TW9 4BH
Surrey, England

Coralie Armstrong 74
P.O. Box 22
Inglewood, SA 5133
Australia

Linda Bacon 88
Box 378
Ross, CA 94957

Judith Hurst Baer 116
24702 Via Valmonte
Torrance, CA 90505-6803

Hella Bailin, A.W.S. 81
829 Bishop Street
Union, NJ 07083

Margo Bartel 25
3416 Bilglade Road
Fort Worth, TX 76133-1407

Pat Berger 15
2648 Anchor Avenue
Los Angeles, CA 90064

John C. Bermingham, A.W.S. 130
245 S. Main Street
Wharton, NJ 07885

**Dorothy W. Bertine, S.W.S.,
S.W.A., A.C.A. 52**
913 Chasewood Lane
Denton, TX 76205-8203

Judi Betts, A.W.S. 67
P.O. Box 3676
Baton Rouge, LA 70821-3676

Jennifer D. Boget 99
4002 Dublane Drive
Murrysville, PA 15668

Joseph Bohler, A.W.S. 65
P.O. Box 387
556 Trumbull Lane
Monument, CO 80132

Joan M. Boryta 7
133 East Main Street
Plainfield, MA 01070

**Jorge Bowenforbés, A.W.S.,
N.W.S. 21**
P.O. Box 1821
Oakland, CA 94612

Angela Bradburn 62, 63
625 Shadow Brook Drive
Columbia, SC 29210

Jack R. Brouwer, A.W.S. 26
2231 Meadowglen Drive NE
Grand Rapids, MI 49505

Jerry H. Brown 109, 110
2735 Cogan Drive
Independence, MO 64055

Daryl Bryant 13
2309 La Engina Way
Pasadena, CA 91107

Rich Buchwald 98
12997 La Tortola
San Diego, CA 92129-3057

Margaret Ebbinghaus Burch 11
Route 1, Box 287
Anderson, MO 64831

Dottie Burton 86
1916 Bay Hill Drive
Las Vegas, NV 89117

Ranulph Bye, N.A., A.W.S., D.F. 31
P.O. Box 362
Mechanicsville, PA 18934

Nel Byrd 48
1933 Shadow Trail
Plano, TX 75075

S. Ohrvel Carlson 33
43 Broadway
Rockport, MA 01966

Pamela Caughey 107
363 Owings Creek Road
Hamilton, MT 59840

Allison Christie 30
521 Spring Valley Road NW
Atlanta, GA 30318-2640

Jean Cole 24
78 Ash Street
Denver, CO 80220

Elizabeth Concannon 100
12616 Villa Hill Lane
St. Louis, MO 63141

Jack Denney 37
700 A. Bordeaux Court
Elk Grove Village, IL 60007

Pat Dews, A.W.S., N.W.S. 76
13032 SE Coghill Court
Hobe Sound, FL 33455

Brad Diddams 70
1210 W Tulane Drive
Tempe, AZ 85283

Henry W. Dixon, N.W.S., K.W.S. 35
8000 E 118th Terrace
Kansas City, MO 64134

Jeanne Dobie, A.W.S., N.W.S. 129
160 Hunt Valley Circle
Berwyn, PA 19312-2302

Liz Donovan, N.W.S. 133
4035 Roxmill Court
Glenwood, MD 21738

J. Everett Draper, A.W.S. 97
P. O. Box 12
Ponte Vedra Beach, FL 32004

Deborah Ellis 93
423 South Lee Street
Alexandria, VA 22314

Harriet Elson 40
10 N Main Street
Munroe Falls, OH 44262

Jacquelyn Fleming 138
36838 Woodingham Drive
Clinton Township, MI 48035

Yolanda Frederikse 6
9625 Dewmar Lane
Kensington, MD 20895

Karen Frey 126
1781 Brandon Street
Oakland, CA 94611

Henry Fukuhara 90
1214 Marine Street
Santa Monica, CA 90405

Louis Stephen Gadal, N.W.S., A.S.M.A 120
3648 Coolidge Avenue
Los Angeles, CA 90066

George Gibson, N.A., A.W.S., N.W.S. 39
1449 Santa Maria Avenue
Los Osos, CA 93402

James J. Gleeson 85
148 Precita Avenue
San Francisco, CA 94110

Barbara Goodspeed 75
11 Holiday Point Road
Sherman, CT 06784-1624

Revelle Hamilton 106
131 Mockingbird Circle
Bedford, VA 24523

Ken Hansen, N.W.S. 92
241 JB Drive
Polson, MT 59860

Robert E. Heyer 27
102 Booream Avenue
Milltown, NJ 08850

Amanda Jane Hyatt 71, 72
25 Culzean Crescent
Highton 3216 Victoria
Australia

Yumiko Ichikawa 101
1706 Downey Street
Radford, VA 24141

Edwin L. Johnson 69
7925 N Campbell Street
Kansas City, MO 64118-1521

Jack Jones 105
391 Maple Street
Danvers, MA 01923

Marshall W. Joyce 104
5 River Street
Kingston, MA 02364

Jean Kalin, A.P.S.C., K.W.S. 10
11630 NW 64th Street
Kansas City, MO 64152

M. C. Kanouse 42
308 Mill Street
P. O. Box 782
Sheridan, MT 59749

Ruth Karp 124
44 Bal Bay Drive
Bal Harbour, FL 33154

Sandy Kinnamon 128
3928 New York Drive
Enon, OH 45323

Pat Kochan 68
3727 Blue Trace Lane
Dallas, TX 75244

George E. Kountoupis 1, 18, 19
5523 E 48th Place
Tulsa, OK 74135

Priscilla E. Krejci 22
4020 Fiser
Plano, TX 75093

Frederick T. Kubitz, A.W.S., N.E.W.S. 12
12 Kenilworth Circle
Wellesley, MA 02181

Carol La Chiusa 132
418 Barclay Road
Grosse Pointe Farms, MI 48236

Carolyn D. Latanision 127
28 Nassau Drive
Winchester, MA 01890

Michael Lenn 121
1638 Commonwealth Avenue, Suite 24
Boston, MA 02135

Monroe Leung, N.W.S., A.W.S 28
1990 Abajo Drive
Monterey Park, CA 91754

Nat Lewis 29
51 Overlook Road
Caldwell, NJ 07006

Ward P. Mann 8
163 Stony Point Trail
Webster, NY 14580

Joe Manning 137
5745 Pine Terrace
Plantation, FL 33317

Margaret R. Manring 14
3713 Highland Avenue
Skaneateles, NY 13152

Daniel J. Marsula, A.W.S., M.W.S. 53
2828 Castleview Drive
Pittsburgh, PA 15227

Jule McClellan 47
2805 Tippecanoe Trail
Henderson, KY 42420

John McIver, A.W.S., N.W.S., W.H.S. 51
P.O. Box 9338
Hickory, NC 28603

Joan H. McKinney 118
1095 West Brook Road
Bridgewater, NJ 08807

Susan McKinnon, N.W.S. 139
2225 SW Winchester
Portland, OR 97225

Joanna Mersereau 23
4290 University Avenue
Riverside, CA 92501

Robert T. Miller, A.W.I., F.V.A.S. 60
Unit 187 Cumberland View Whalley Drive
Wheelers Hill, VIC 3150
Australia

Barbara Millican, N.W.S. 102
5709 Wessex
Fort Worth, TX 76133

Judy Morris, N.W.S. 58
2404 E Main Street
Medford, OR 97504

Barbara Nechis 3, 54
1085 Dunaweal Lane
Calistoga, CA 94515

Lael Nelson 17
600 Lake Shore Drive
Scroggins, TX 75480

Alice A. Nichols 80
33002 Maplenut
Farmington, MI 48336

Paul W. Niemiec, Jr. 50
P. O. Box 674
Baldwinsville, NY 13027

Don O'Neill, A.W.S. 79
3723 Tibbetts Street
Riverside, CA 92506

Jane Oliver 78
20 Park Avenue
Maplewood, NJ 07040

Robert S. Oliver, A.W.S., N.W.S. 34
4111 E San Miguel
Phoenix, AZ 85018

Linda Banks Ord 136
11 Emerald Glen
Laguna Niguel, CA 92677

Gloria Paterson, N.W.S. 36
9090 Barnstaple Lane
Jacksonville, FL 32257

Donald W. Patterson 57
441 Cardinal Court N
New Hope, PA 18938

Ann Pember 38
14 Water Edge Road
Keeseville, NY 12944

Janet Poppe 82
803 County Line Road
Highland Park, IL 60035

Dolores V. Preston 61
165 Marian Parkway
Crystal Lake, IL 60014

Joan Rademacher 96
26 Milk Avenue
Methuen, MA 01844

Richard P. Ressel 89
1010 Fountain Avenue
Lancaster, PA 17601

Michael P. Rocco, A.W.S. 66
2026 S. Newkirk Street
Philadelphia, PA 19145

Jerry Rose 125
700 Southwest 31st Street
Palm City, FL 34990

Robert Sakson, A.W.S., D.F. 9
10 Stacey Avenue
Trenton, NJ 08618-3421

Nicolas P. Scalise 83
59 Susan Lane
Meriden, CT 06450

Betty Lou Schlemm, A.W.S., D.F. 140
Caleb's Lane
Rockport, MA 01966

Susan C. Schultz 123
311 Superior Avenue
Decatur, GA 30030

Ken Schulz, A.W.S. 43
P.O. Box 396
Gatlinburg, TN 37738

Barbara Scullin 111
128 Paulison Avenue
Ridgefield Park, NJ 07660

Fran Scully 87
170 East Street So.
Suffield, CT 06078

F. Charles Sharpe 134, 135
4617 Reigalwood Road
Durham, NC 27712

George J. Shedd, A.W.S., A.A.A., N.E.W.S. 44, 45
46 Paulson Drive
Burlington, MA 01803

Morris J. Shubin 49
313 N 12th Street
Montebello, CA 90640

Edwin C. Shuttleworth, F.W.S. 46
3216 Chapel Hill Boulevard
Boynton Beach, FL 33435

Cindy Posey Singletary 94
1079 Judy Lane
Benton, LA 71006

Dorla Dean Slider, A.W.S. 55, 56
268 Estate Road
Boyertown, PA 19512

George Sottung, A.W.S. 73
111 Tower Road
Brookfield, CT 06804

Nancy M. Stark 131
1027 Chestnut Drive
Harrisonburg, VA 22801

Caleb Stone 113
45 Washington Street #3
Methuen, MA 01844

Kathy Miller Stone 119
5125 Greenside Lane
Baton Rouge, LA 70806-7139

Richard J. Sulea 32
660 E 8 Street
Salem, OH 44460

Virginia Abbate Thompson 16
10776 S.W. 88 Street, Apt. F-21
Miami, FL 33176

Gregory B. Tisdale 41
35 Briarwood Place
Grosse Pointe Farms, MI 48236

Libby Tolley, N.W.S. 95
2116 Inyo Drive
Los Osos, CA 93402

James Toogood, A.W.S. 112
920 Park Drive
Cherry Hill, NJ 08002

Beth Patterson Tooni, N.W.S. 108
21 Jensen Avenue
Chelmsford, MA 01824-2247

Pat Truzzi 122
5010 Willis Road
Grass Lake, MI 49240

Anthony Ventura 20
3430 Highway 66
Neptune, NJ 07753

Veloy J. Vigil 103
224 N Guadalupe
Sante Fe, NM 87502

Robert A. Wade, A.W.I., F.V.A.S., F.R.S.A., K.A., I.S.M.P., MHSMA 115
524 Burke Road
Camberwell, 3124 Victoria
Australia

Donna L. Watson 84
19775 S.W. Taposa Place
Tualatin, OR 97062

Kitty Waybright 77
1390 Bailey Road
Cuyahuga Falls, OH 44221

Alice W. Weidenbusch 91
1480 Oakmont Place
Niceville, FL 32578-4314

Sharon N. Weilbaecher 114
31 Plover Street
New Orleans, LA 70124

Joyce Williams, A.W.S., N.W.S. 59
Box 192
Tenants Harbor, ME 04860

Douglas Wiltraut 64
969 Catasauqua Road
Whitehall, PA 18052

glossary

analogous colors: the shades, tints, or tones of any three colors that are next to each other on the color wheel

background: the part of the painting that appears to be farthest from the viewer

balance: the even distribution of shapes and colors in a painting

bristol board: a stiff, durable cardboard made in plate and vellum finishes with thicknesses of one- to four-plies

cold press paper: paper with a medium-rough texture as a result of being pressed with cold weights during processing

collage: process of constructing flat (or low relief) two-dimensional art by gluing various materials (i.e. newspaper, photographs, etc.) onto the painting surface

complementary colors: any two colors that are opposite each other on the color wheel (i.e., red and green) which create a high contrast when place side by side

contrast: the juxtaposition of extremes within the compositions in colors (purple with orange), values (white with black), textures (coarse with smooth), etc.

crayon resist: a technique in which crayon is applied to the surface and repels the paint that is applied afterward

crosshatching: brushstrokes applied at right angles to each other to create contrasting tone and density

dapple: to mark or patch with different shades of color

drybrush: a method of ink or watercolor painting in which most of the pigment has been removed from the brush before application

foreground: the part of the painting that appears to be closest to the viewer

gesso: a paste prepared from mixing whiting with size or glue and spread upon a surface to fit it for painting or gilding

gouache: a method of painting with opaque colors that have been ground in water and mingled with a preparation of gum

hot press paper: paper with a smooth surface as a result of being pressed between calendar rollers that flatten the grain into an even finish

hue: the actual color of anything—also used to describe what direction a color leans toward, (i.e. bluish-green, etc.)

illustration board: layers of paper adhered to a cardboard backing to produce a sturdy drawing surface, made in various thicknesses and textures

local color: the true color of an object seen in ordinary daylight

museum board: available in two- and four-ply, this soft, textured surface absorbs wet or dry pigment readily; usually used in archival malting and framing of artwork.

saturation: the intensity or brightness of color

shade: the color achieved when black is added to a hue

spatter: to scatter color on the canvas by splashing on paint

stipple: to create an optical mix of colors through the use of dots or dashes

tint: color achieved when white or water is added to a hue

tooth: refers to the depth of the grain of paper

value: the relative lightness or darkness of a color

vellum: a smooth, cream-colored paper resembling calfskin

wash: a thin, usually transparent coat of paint loosely applied to the surface of the canvas